ULTIMATE
ILLUSTRATION!

enter

DO NOT

Ultimate Illustration!

HarperCollins books may be purchased for educational, business, or sales promotional use. For information, please write: Special Markets Department, HarperCollins*Publishers*, 10 East 53rd Street, New York, NY 10022.

First published in 2008 by:
Collins Design
An Imprint of HarperCollins*Publishers*
10 East 53rd Street
New York, NY 10022
Tel: (212) 207-7000
Fax: (212) 207-7654
collinsdesign@harpercollins.com
www.harpercollins.com

Distributed throughout the world by:
HarperCollinsPublishers
10 East 53rd Street
New York, NY 10022
Fax: (212) 207-7654

Editor
Josep Mª Minguet

Art directions, text, and layout
Eva Minguet Cámara

Translation
Babyl Traducciones

Library of Congress Control Number: 2008924674

ISBN: 978-0-06-168602-3

Printed in Spain
First Printing, 2008

The typeface SALAMI EXTRA was designed by Ipsum Planet for *Neo2* magazine (www.neo2.es).

Page one: Exit by Skizzomat (digital collage).
Right page: I Carved Your Name With A Heart Just Up Above by Ben the Illustrator (Hand-drawn, artworked in Illustrator).

ULTIMATE
ILLUSTRATION!

eva minguet cámara

COLLINS DESIGN
An Imprint of HarperCollins Publishers

ILLUSTRATORS

The interview consists of five questions:
We have thought that to do the most didactic book the answers seen in the individual profiles are in response to the questions listed here.

1. Define yourself as an illustrator.
2. Discuss your techniques.
3. Who are your favorite illustrators?
4. Which sector (magazines, fashion, comic, advertising) do you think your work is best suited for?
5. How do you see yourself and your art in the future?

This publication brings us more than 300 illustrations from artists all over the world.

Ultimate Illustration! is a stimulating publication cocktail of very different styles with more than 300 illustrations by artists from different countries whose ideas go far beyond the traditional.

Illustration is an essential element in visual communication in today's world. With unlimited creative resources, it can be as wild as the imagination and incorporate a wide variety of techniques. Illustration has become an international language.

Each entry consists of a selection of the artist's most recent works, their contact information, and an interview in which they discuss their skills, publications, style and philosophy.

This book is perfect not only for creative professionals and illustration students, but all those who take pleasure in the language of illustration.

Left page: Anra by Ana Bagayan (oil on panel).

Julie West

UK www.juliewest.com helloj@juliewest.com

All images © Julie West

1. I have known since I was a small child that I would do art of some sort but it was not clear until I studied at University that I would become an Illustrator. Illustration just seemed to fit since a lot of my work is story based.

2. I love working across many media, it keeps me from getting bored. I work both traditionally and digitally, and I love working in new formats, such as toys or other 3D objects.

3. My favorite illustrators are Tim Biskup and Joe Sorren. I don't think their work directly influences me, but I respect their work and what they have achieved.

4. I think my style is rather specific but I seem to work well across multiple media. I have been hired to do all sorts of different things.

5. It's difficult to gauge where I will go next—I just know that if I can continue doing this I will be happy. I consider myself very fortunate that I get to create art all day.

Froghead Girl
Vector illustration.
2006

Miss Petits Gateaux
Vector illustration.
2007

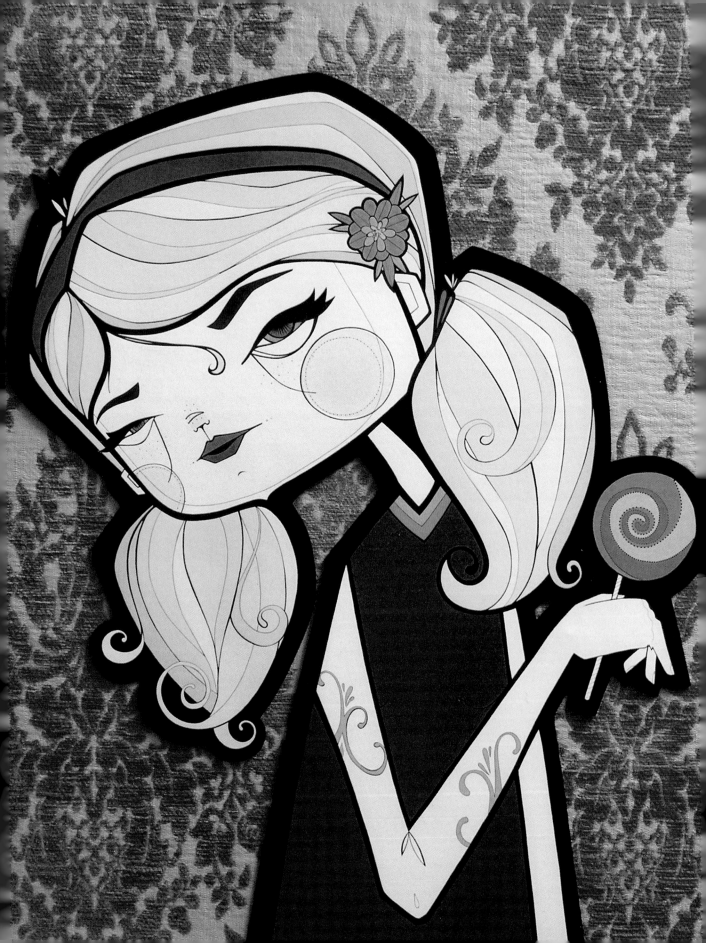

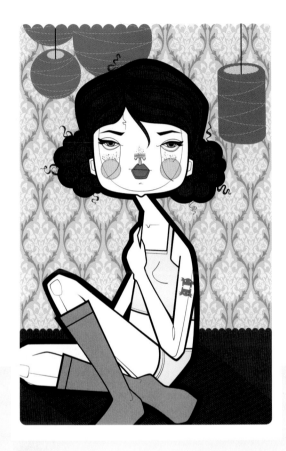

Splendid
Vector illustration.
Limited edition screenprint.
2007

Speaking of clouds
Vector illustration.
Limited edition screenprint.
2006

Lolly Lolly
Acrylic, gouache, ink on paper and fabric.
2007

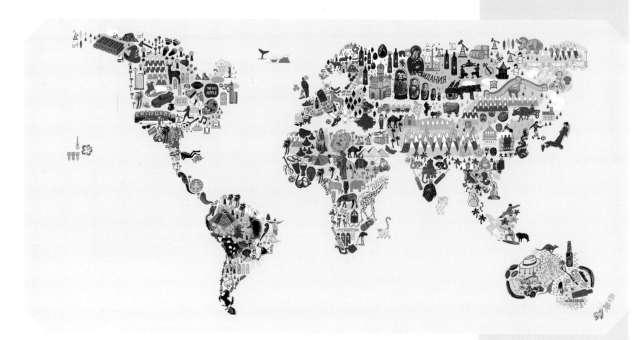

World map
Hand-drawn, digital.
Vodafone.
2006

Leisure traveller–City
Hand-drawn, digital.
Vodafone.
2007

Serge Seidlitz

UK www.sergeseidlitz.com mail@sergeseidlitz.com

All images © Serge Seidlitz

1. I grew up traveling between the UK and Asia, where my exposure to modern Chinese art, *Mad* magazine, a diet of MTV, and the dangerous life of a foreign-correspondent father, fuelled my desire to become an illustrator. After studying graphic design at Camberwell College of Art I started working in-house at The Cartoon Network and now work freelance from my studio in Farringdon and working with an ever-evolving list of clients, including MTV, VH1, Volvic, Orange, JWT, FUSED, John Brown, *The Times*, BBH, Leo Burnett, RKCR/Y&R, Hicklin Slade, Honda, Vodafone, Baileys, *The Guardian*, and *NME* magazine. I am represented in London by Debut Art.

2. I use pens, pencil, brushes, Illustrator, and Photoshop.

3. I'm inspired by all kinds of artists. Off the top of my head, I'd say, Hieronymus Bosch, Tadanori Yoko, John Pound, Saul Steinberg, Blanquet, Chris Ware, and many more.

4. I am currently working a lot within the advertising and editorial sectors, I would like to work on some comics for myself in the future.

5. I'm planning to do a book collaboration with an author friend and I'd love to do a one-man show but I'd need to take the time from the commercial stuff in order to do so.

Manchester International festival
Hand-drawn, digital.
Love Creative.
2007

Leisure traveller–Beach Hand-drawn, digital. Vodafone. 2007

Josh Cochran

USA www.joshcochran.net mail@joshcochran.net

All images © Josh Cochran

1. Like most artists, I've been drawing and painting since I was very young. I decided to pursue art and illustration as a career and attended design school. After graduating from the Art Center here in Los Angeles, I got my first big break from Steven Heller at the *New York Times Book Review*. He gave me a lot of work, which helped me get off to a running start! Since then, my illustrations have been commissioned by companies including Pepsi, Sony Music, Kiehl's, and the *New Yorker*. My influences include Japanese ukiyo-e prints, modern architecture, French comic books, film, and contemporary graphic design. I currently live in Los Angeles and work out of a studio/gallery space in Koreatown.

2. I like to draw really small thumbnails, super loose and messy. Then, I blow them up, and start drawing in a corner until the entire piece is finished. I try not to do too much lay-in, because I feel it might stiffen up my compositions. Color is then added in Photoshop. When I go to silkscreen, it's basically the same method to prep.

3. I'm constantly changing my favorite artists, but right now, I've really been into Marian Bantjes and an awesome French artist, Nicolas de Crécy.

4. At the moment, my work is mostly directed toward magazines and advertising.

5. I would like to be published eventually in comics or some sort of picture book. I would also like to create more motion projects and gallery shows in the future.

Escape!
Digital.
2007

Bigfoot
Digital.
2007

Page 18/19
Mutants and Monsters
Digital.
2007

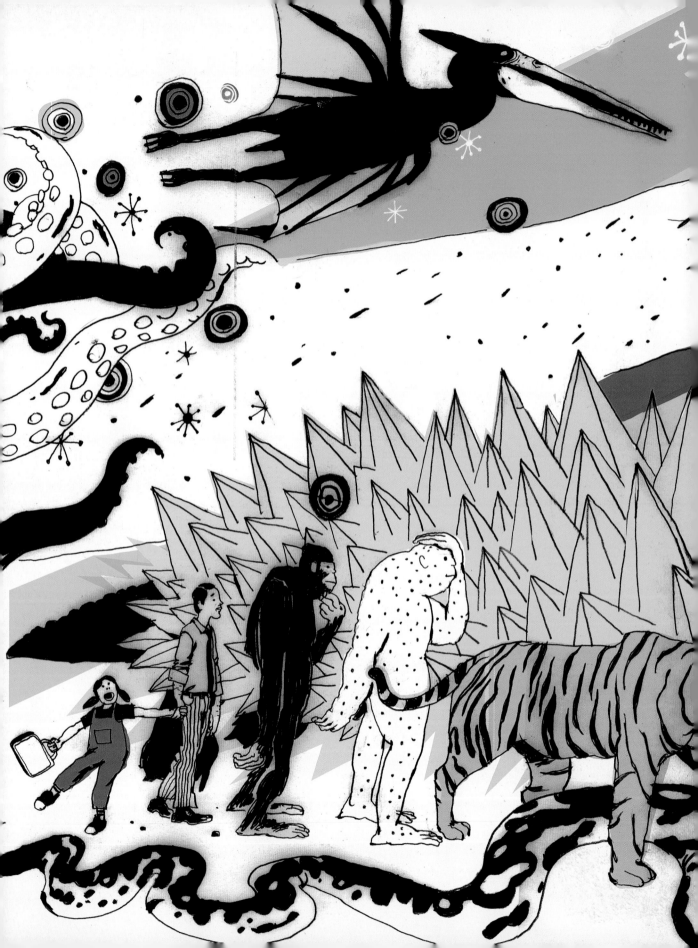

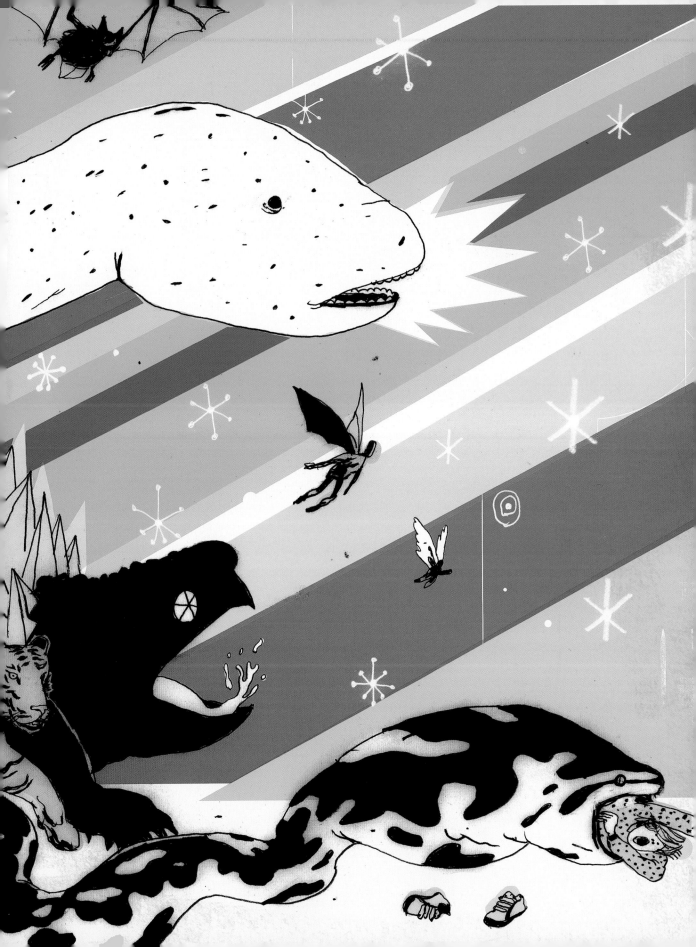

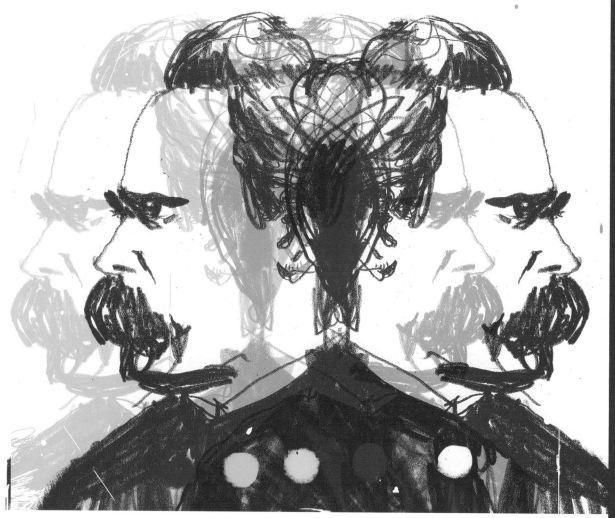

Friedrich Nietzsche
Digital.
2005

100 Cars
Digital.
2007

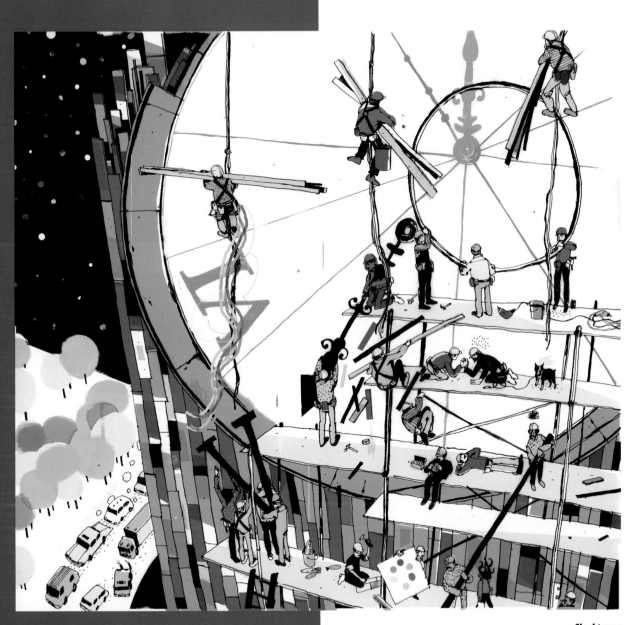

Clocktower
Digital.
2006

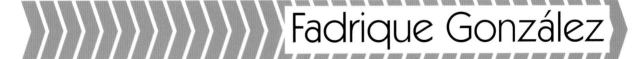

Fadrique González

Spain www.fafafa.es contacto@fafafa.es

All images © Fadrique González

1. I began to draw at the time I was first able to reason, but never considered making it my profession until I was 27.

2. Nowadays, I mainly use vector programs and Photoshop. At times I make use of special textured finishes on my illustrations, which add a certain hue and tint to give the illustrations an aged and soiled appearance.

3. I have many favorite artists, with completely different styles. I am very fond of Jeff Soto and also Shag. I love the way Jeremyville goes overboard with everything. And perhaps one of my favorites, and for whom I have a special affection, is Jim Phillips. From Spain I have a great liking for Sonia Pulido, LeCadavre, and I adore what appears on the streets from 3TT.

4. I don't know for sure, but I believe I would do well in magazines and in publicity. One thing I would like to get into is animation. I think my drawings might be well suited for that.

5. This is how I hope to earn a living in the short term but, in the long term, I have no idea of what might happen or what might become of somebody like me.
 I rather like the idea of holding exhibitions, this is something I would like to get into right away.

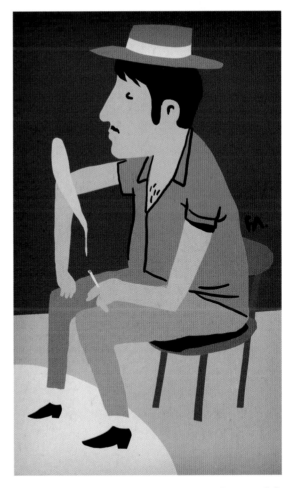

Man on a chair
Vector illustration, Photoshop.
2007

Forest
Vector illustration, Photoshop.
2007

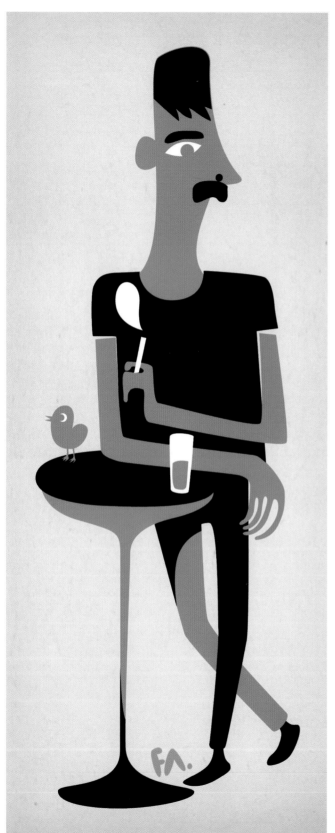

Big moustache
Vector illustration, Photoshop.
2007

Live show poster
Vector illustration, Photoshop.
2007

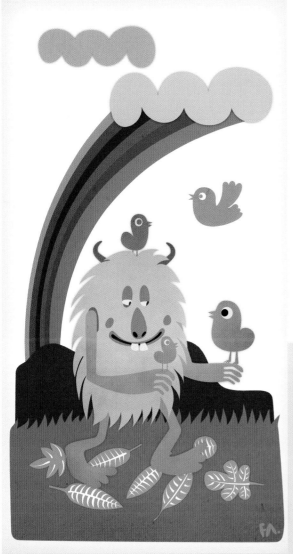

Rainbow
Vector illustration, Photoshop.
2007

Nightmare
Vector illustration, Photoshop.
2007

Ben the Illustrator

UK www.bentheillustrator.com hello@bentheillustrator.com

All images © Ben the Illustrator

1. Drawing was always my love, from early childhood. I studied animation at university and went on to direct and animate music videos. I then became creative director of a small London-based design agency, which was great, but it was the illustration jobs I did that were my real love, so I left this position and became Ben the Illustrator. Two years since going solo, I am inspired by nature and my own surroundings, and now I'm working for a great variety of clients, producing dreamy landscapes and fresh views!

2. I always draw my illustrations first, in full, on paper. It's important to think through exactly what you're trying to show, to make sure it has the right feeling. Then, I take my drawing into Adobe Illustrator to artwork it. I love the precision and depth of the software, there is so much to it, the colors are fantastic and the line control is incredible.

3. Since childhood, I have been inspired by Brian Cook, a British book jacket artist who used wild colors to create beautiful landscapes. I am especially excited by the early 1980s New York graffiti artists, the film *Style Wars* is a perfect reference for fresh art and culture.

4. I already work in editorial and advertising, but would love to have the opportunity to work on a comic book. To collaborate with a strong comic book writer would be amazing.

5. I would like to continue working with my wife Fi, forever producing fresh and colorful artwork. I aim to work more in exhibitions in the near future, especially taking my character Speakerdog around the world in a variety of exciting exhibitions. One day, I also hope to take some time away from all the other projects and focus solely on creating a fully illustrated children's book.

Speakerdog loves thunder chunky!
Hand-drawn, artworked in Illustrator.
2007

Move away and shine
Hand-drawn, artworked in Illustrator.
2007

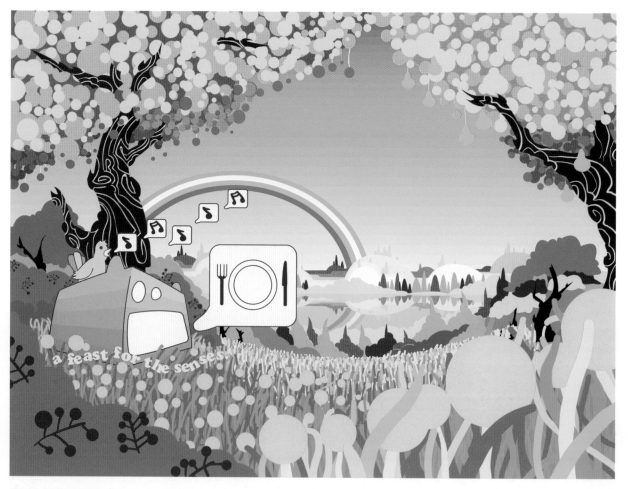

A feast for the senses
Hand-drawn, artworked in Illustrator.
2007

Play
Hand-drawn, artworked in Illustrator.
2007

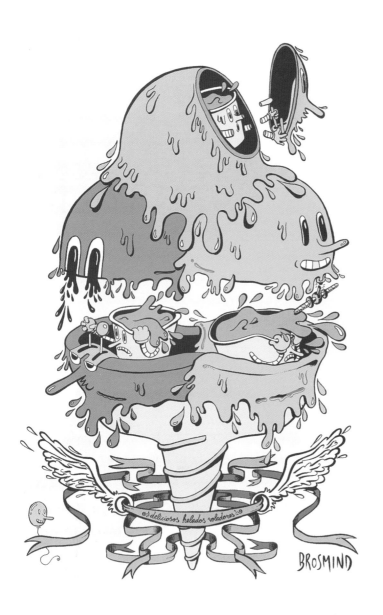

3 flavors ice-cream
Ink on paper, digital color.
2006

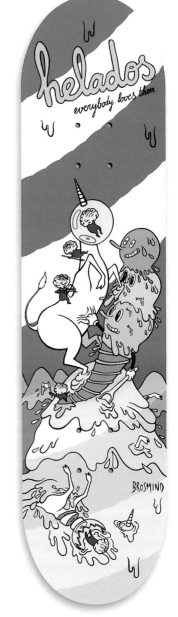

Skateboard
Ink on paper, digital color.
2007

Brosmind

Spain www.brosmind.com info@brosmind.com

All images © Brosmind

1. Our illustrations are a mixture of fantasy and surrealist humor. We like to enhance our drawings by swamping them with minute details. For some strange reason, birds and ice cream are a constant feature in our work.

2. We work in a fairly traditional way. We make rough pencil sketches and afterward shade in with a paintbrush or felt-tip pens. We then scan the original and apply the color by computer.

3. Immediately brought to mind are Charles Burns, Marc Ryden, Dave Copper, Robert Crumb, Tim Biskup, Gary Baseman.

4. Our style is fairly versatile, and we have worked in many different fields. We are currently working mainly for publicity agencies.

5. This is an unpredictable world, but we hope to be able to have more time to work on developing our own personal projects.

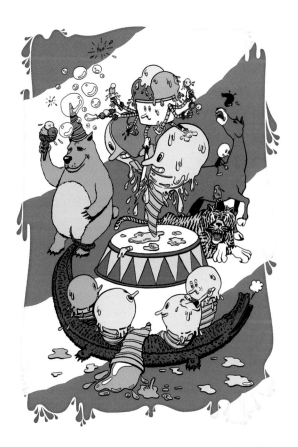

Ice-creams, Bear, Cocodrile...
Ink on paper, digital color.
2006

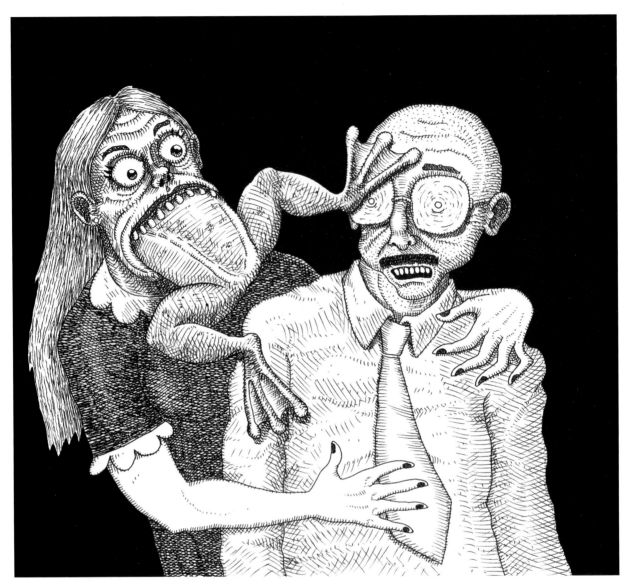

Frog inside the mouth
Ink on paper.
2006

Robots with keyboards and birds
Ink on paper.
2006

Steve Lawson

UK www.stevelawsonart.com bloodyspaulding@aol.com

All images © Steve Lawson

1. My decision to become an artist and illustrator goes back to my childhood, when I marvelled at illustrations that filled me with joy, sadness, and inspiration.

 I've always been quite an introverted person, and I fill my head with oddball ideas and concepts on a day-to-day basis. The progression to artist and illustrator was inevitable.

 Having exhibited my paintings around the UK, I have taken small illustration projects including CD covers for unsigned bands and book jackets for first-time authors.

2. My techniques are mainly oil on canvas, as well as acrylics on canvas, although, if need I will sometimes work entirely on a computer, depending on the commission in time, and what I want to achieve and feel would suit the brief best.

3. Many influences within all aspects of the arts. My favorite artist/illustrators would have to be HR Giger, Phil Hale, Kent Williams, Brandt Peters, and so many more.

4. I love a challenge so, in terms of where to aim my work I feel I can make it appealing in any media. Of course, I do love book jackets, comics, and novels, as well as CD covers.

5. Being self-taught and quite new to the pro illustrator market it's early days for me but it's looking good and I'll be around for a very long time. I'm planning on exhibiting again after a short break, as well as working on a children's book which I will be illustrating between projects.

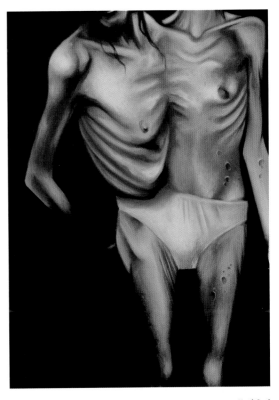

Untitled
Oils on canvas.
2007

Self portrait, Me myself and I
Acrylics on canvas.
2007

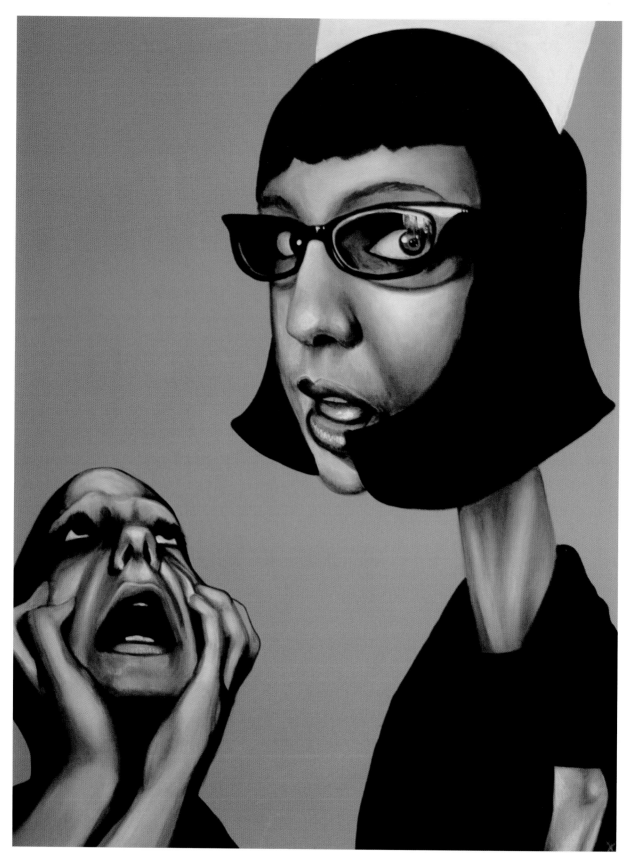

Masks of glass
Acrylics on canvas.
2006

Bread & Water
Acrylics on canvas.
2006

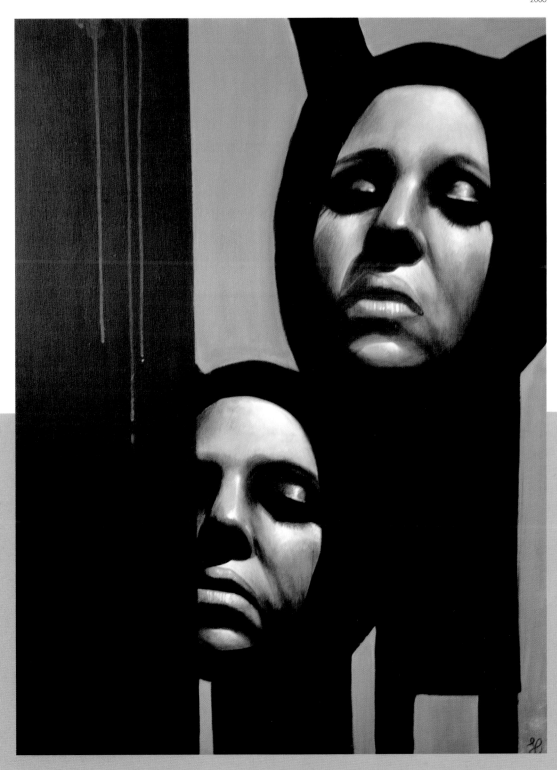

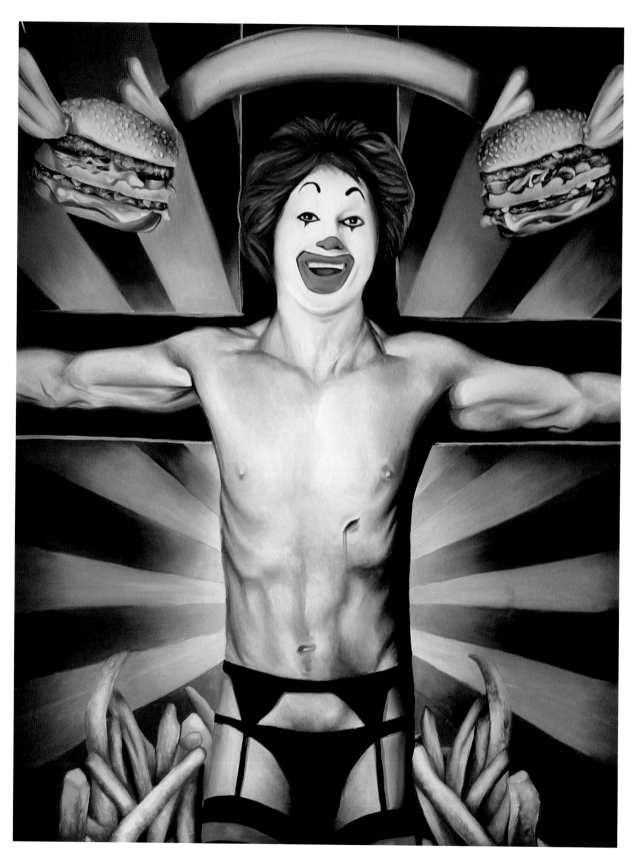

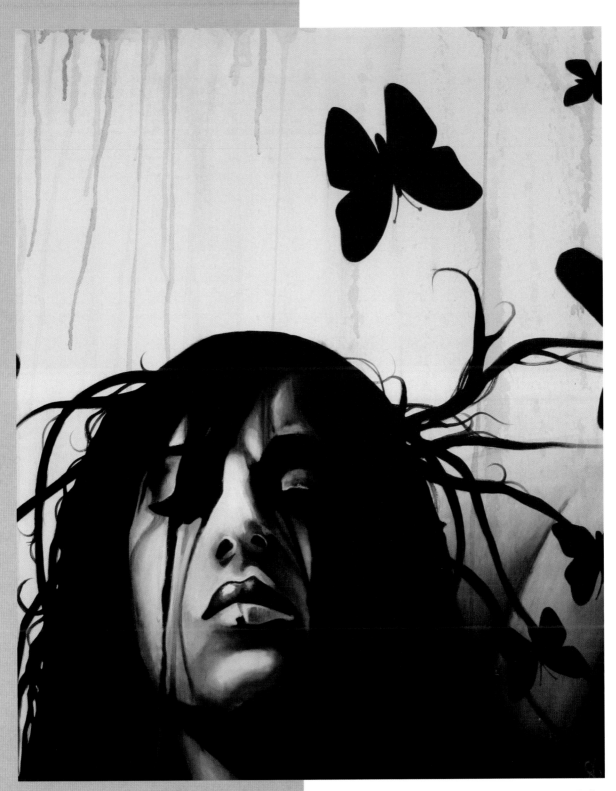

Indigo
Acrylics on canvas.
2006

Cannibalism
Oils on canvas.
2007

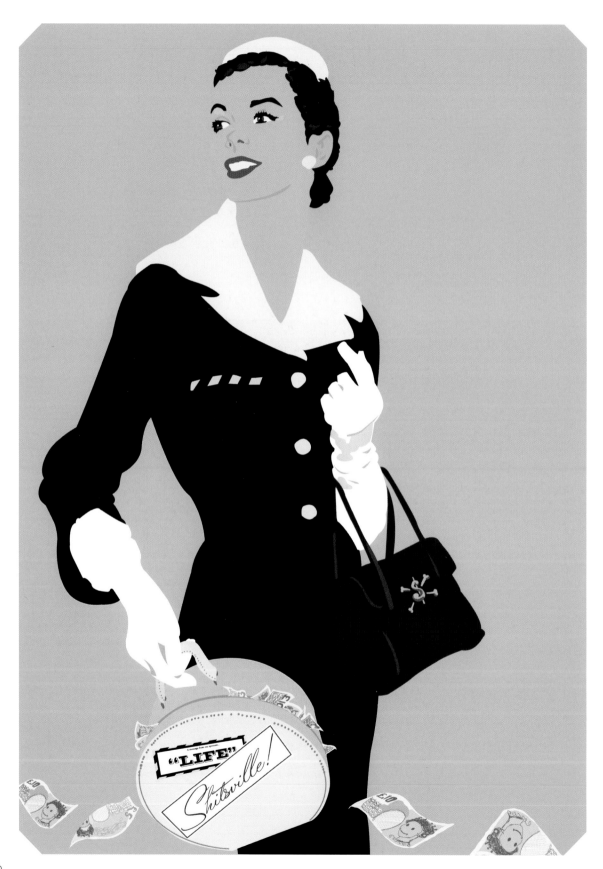

Twisted Fifties

UK www.twisted-fifties.com howdy@twisted-fifties.com

All images © Twisted Fifties

1. The inspiration behind Twisted Fifties' artwork comes from the beautiful artwork of 1950s advertising, an era of wonderfully crafted advertisements. Our love of vintage advertising keeps us blooming and producing images, pocketing inspiration and pilfering imagery from the vintage ads we love. We have created Twisted Fifties' images for magazines including *Cent* and *You*, bands like the art-pop/pop-art band Audioporn and ad clients, including Smirnoff.

2. We start with an idea, a concept we want to twist, then we browse through our collection of vintage advertising, magazines/books, and source imagery, then draw everything together with a trusty pencil. Then it's straight into Adobe Illustrator to artwork it. One of the key factors that makes Twisted Fifties' images work is the color palette: Illustrator's Pantone swatches are priceless! We focus on using a certain subdued set of colors alongside some full vibrant tones and together they mimic the 50s style with a nice 21st century twist.

3. There are thousands of true commercial artists that produced advertising illustrations in the 1950s, too many to name. In our modern age, Twisted Fifties also finds inspiration from many other creative types, including legend Banksy, homewares designer Cath Kidston, and sophisticated fashion designers like Paul Smith.

4. Predominantly magazine editorial, and fashion, but it's always seemed a little niche, working from the 50s style, so we'd like to take our work into a much wider range of sectors, collaborate with fashion designers and so on.

5. We would love to take Twisted Fifties into more galleries around the globe, and work alongside bands creating album artwork that fits perfectly with their music.

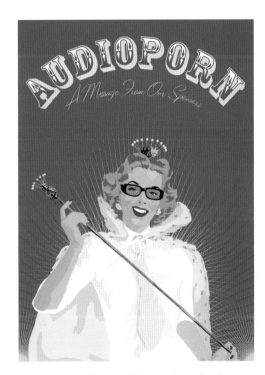

Audioporn - A Message From Our Sponsors
Illustrator.
2007

Last Train From Shitsville
Illustrator.
2007

Chocolate Ice Cream Lady
Illustrator.
2007

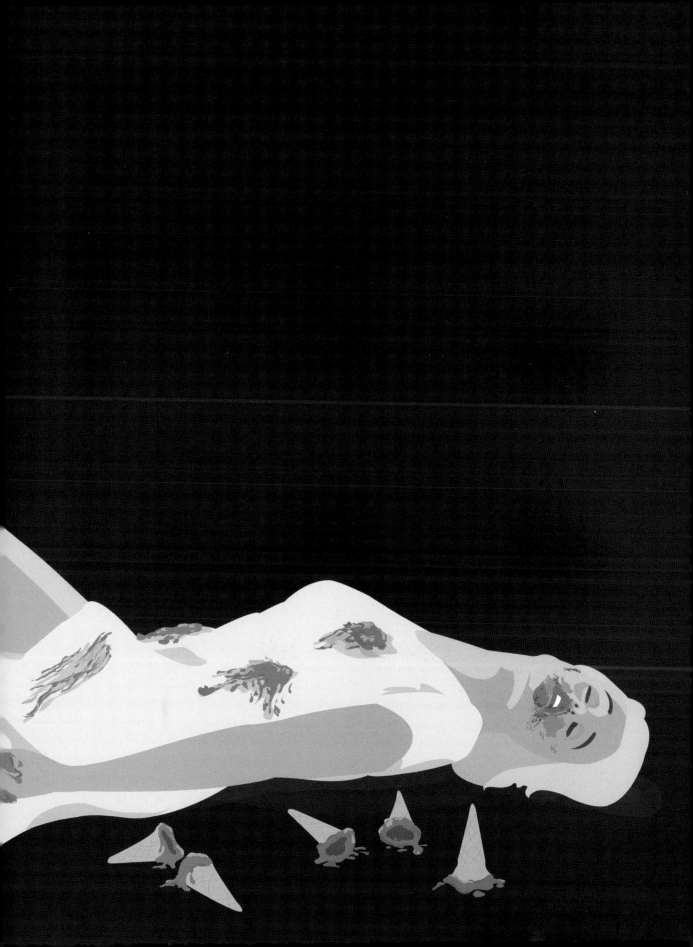

Lighting Up
Illustrator.
2006

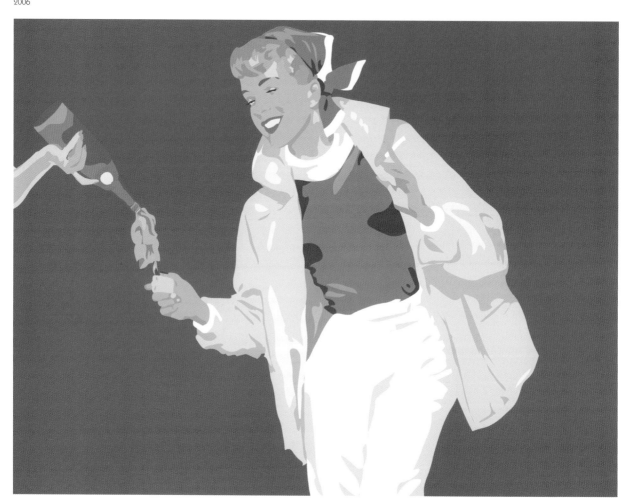

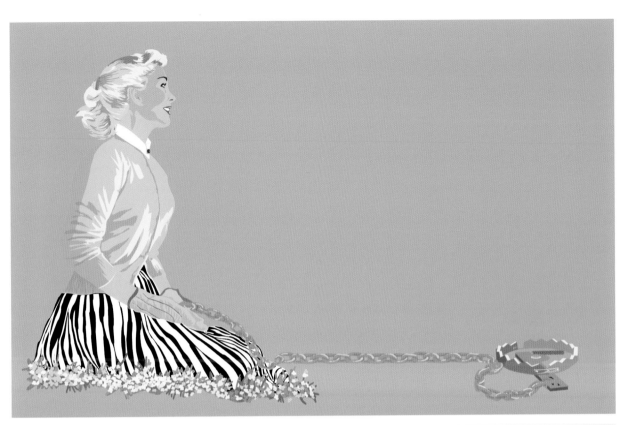

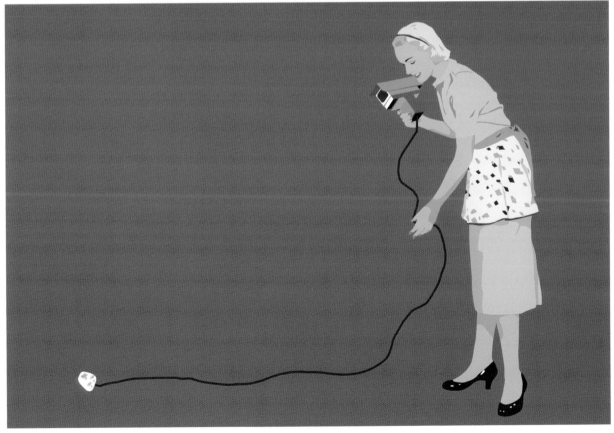

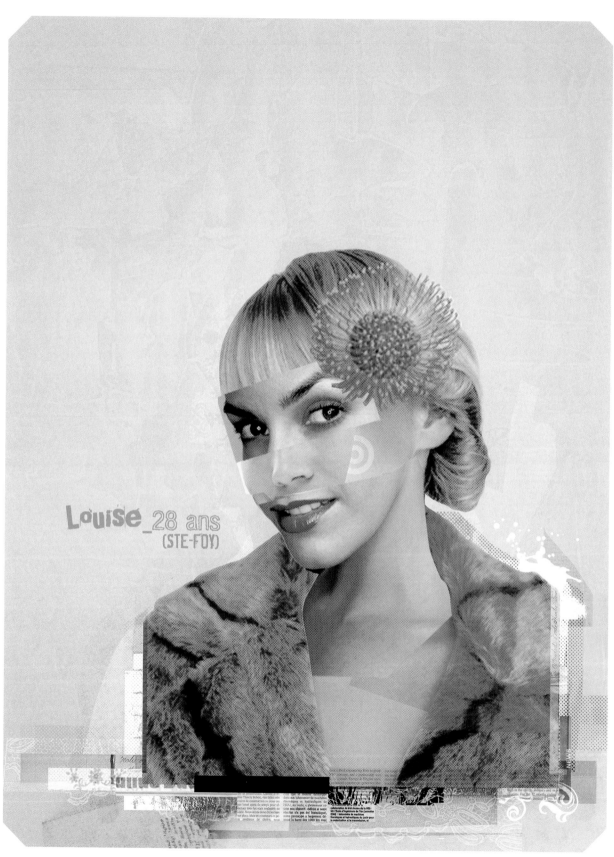

Louise_28 ans
(STE-FOY)

Pablo Pasadas

France www.pablopasadas.com ppasadas@yahoo.com

All images © Pablo Pasadas

1. I began by designing flyers for a club in Paris, Le Divan du Monde. My inspiration usually comes from Baroque art, vintage images from the works of William Burroughs, watching films, listening to electronic music, travelling, and graphic design in general.

2. My technique is creating collages using an assortment of different elements. I take personal photographs from piles of public domain images, a mixture of textures taken from different materials, spray paint, ink blots, vintage, present-day, and Baroque images, the addition of a little etching and all combined in Photoshop, and Illustrator. I like to compare different styles.

3. Eduardo Recife, Neasden Control Centre, Benjamin Savignac, Julien Pacaud, Andy Potts.

4. My work is intended for press journals and and publicity agents.

5. I would like to continue working in graphic design, settle in Barcelona, and continue to work as an illustrator or graphic designer.

Rats
Collage vintage, Photoshop, Illustrator.
2006

Montréal
Collage vintage, Photoshop, Illustrator.
2006

9
Collage vintage, Photoshop, Illustrator.
2007

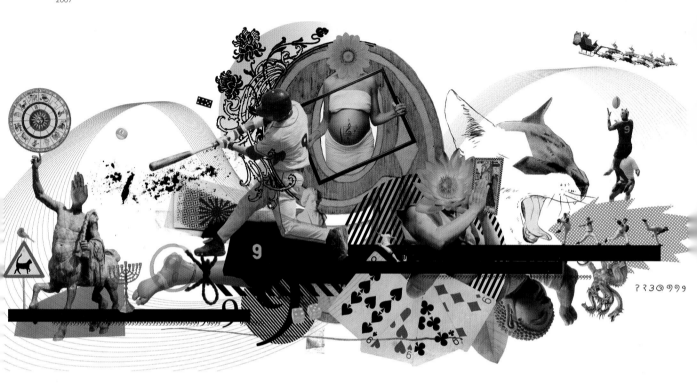

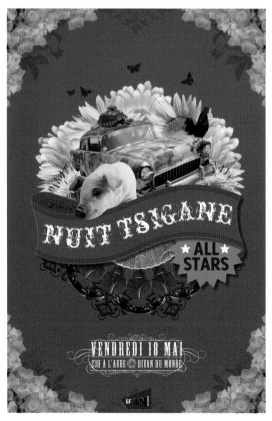

Nuit Tsigane All Stars
Collage vintage, Photoshop, Illustrator.
2006

Cut-Up
Collage vintage, Photoshop, Illustrator.
2007

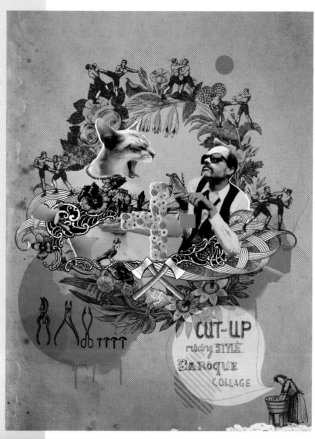

Design Awards
Collage vintage, Photoshop, Illustrator.
2007

Matthieu Marcola

France www.matt-marcola.com arcolamatthieu@free.fr

All images © Matthieu Marcola

1. Since I was a child, I dreamed of becoming an illustrator, the holy grail. Since I was not really happy at school, I worked hard to fill that time in a productive way: I would draw on tables. Then I went for three years to the Epinal School of Image, where I really discovered modern illustration; the other stuff was kind of boring but I had to pretend and open up as well. It took me a while to find my style, but one day everything clicked. Since then I have always been "on." Once I gained confidence, I started drawing professionally. Since 2002, I have very slowly been getting some recognition: children's publications, magazines, games, t-shirts, and so on.

2. I don't really have any secret, frankly; I just try to be somewhat original with the structure of my characters. It is sometimes helpful, sometimes not, when collaborating. But at least people recognize my style!

3. Jacques Tardi inspired me a lot; let's say he is the one who made me want to draw. There are also three funky graphic artists who have a style that is completely different from mine: Les chats pelés (the mangy cats). And of course the man I feel a lot of affection for, the great Marc Boutavant; total respect here!

4. I work with children's magazines, publishing and comics in mind. But if a client is pretty adventurous, we can do a lot; unfortunately, it's not often the case.

5. Absolutely no idea, there are a lot of us. I mostly want to start working on personal projects, like children's stories, scripts for comics. No more, no less. Really, the end goal would be to do books.

Fantômette and Blanky
Drawing on paper, computer coloring.
2007

It's raining
Drawing on paper, computer coloring.
2004

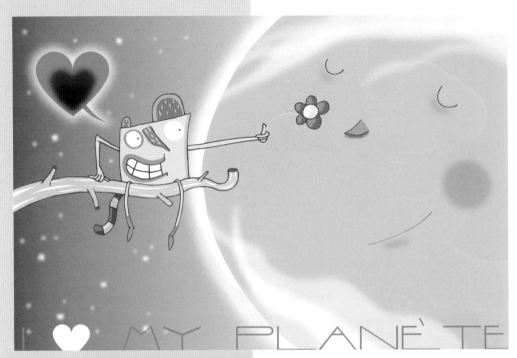

I love my planet I
Drawing on paper,
computer coloring.
2007

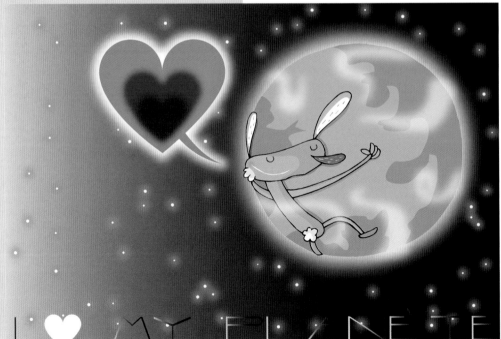

I love my planet II
Drawing on paper,
computer coloring.
2007

Spring
Drawing on paper,
computer coloring.
2004

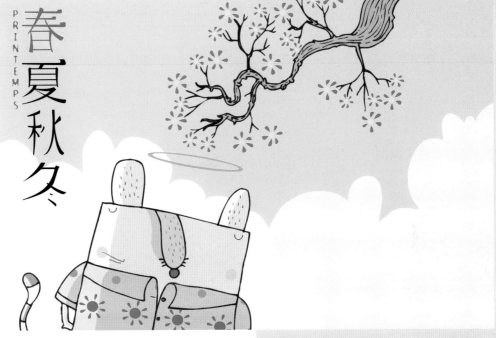

Autumn
Drawing on paper,
computer coloring.
2004

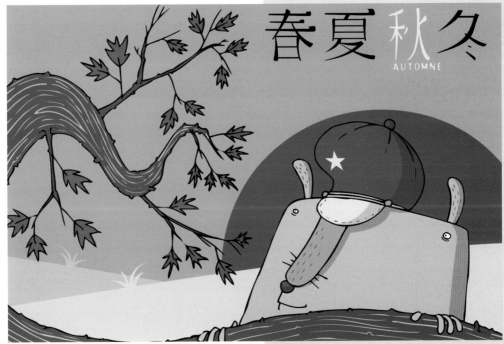

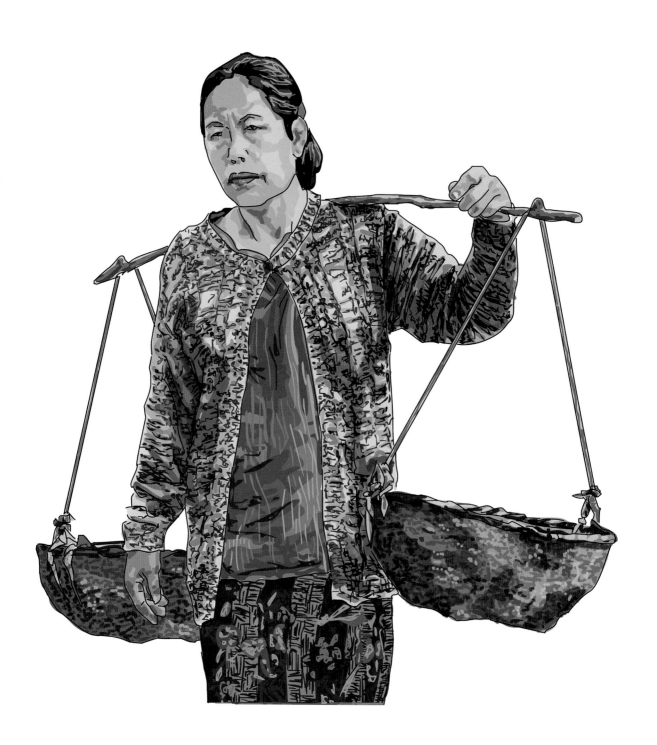

Marta Montoliu

Spain www.martamontoliupaintings.com pigues@hotmail.com

1. I have a basically pictorial background, and began by creating illustrations by way of a more direct way to express my passion for literature. Opportunities came to me through illustration in the editorial field.

2. My current illustrations prioritize the manual treatment of electronic paintbrushes and filters. I use programs with the standard Flash and Photoshop software tools to construct objects with numerous layers of carefully selected colours. The original images are always my own photographs.

3. I have always felt great admiration for the work of illustrator Peret (Pere Torrent), a great influence in my formative years. On the national scene, my inspiration currently comes from the work of Isidro Ferrer, also an illustrator with whom I would like to work in the future.

4. My work is focused on two main areas, both directed at the editorial sector: Illustrating novels and didactic works on the one hand and being involved with publishing novels, magazines, and travel guides on the other.

5. My current projects include working on a new series whereby techniques are introduced that aren't yet fully developed, such as illustrating on different materials. Likewise, I am focusing on the production of digital works, making full use of my professional knowledge regarding technologies from a creative point of view. My future plans include the inclusion of illustrations in my pictorial exhibitions.

Woman, Luang Prabang
Flash.
2006

Woman hindú, Isle of Wight
Flash.
2006

Monk buddhist, Phonsavan
Flash.
2006

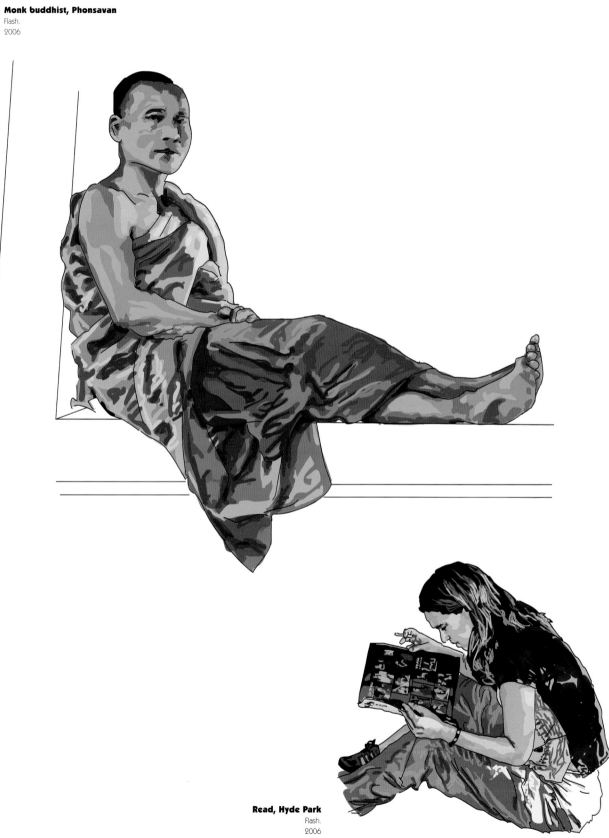

Read, Hyde Park
Flash.
2006

Cleaning shoes, Estanbul
Flash.
2005

Girl, Luang Prabang
Flash.
2006

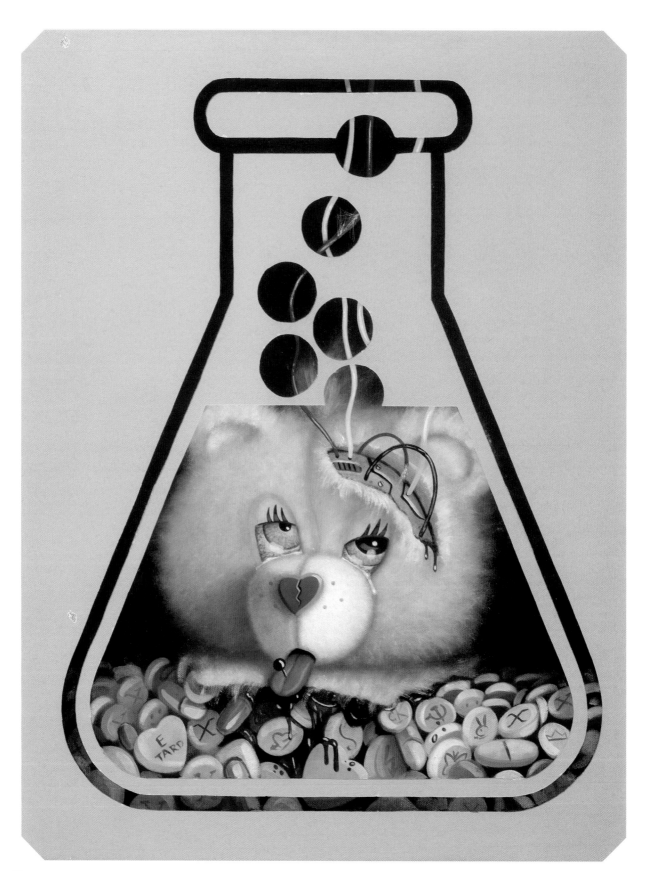

Jason Maloney

USA www.jasonmaloneyart.com jasonmaloneyart@yahoo.com

All images © Jason Maloney

1. I knew that I would be an illustrator, ever since I was child. I started right out of high school doing small illustration jobs for private clients. I also started studying illustration and painting in college. I studied for seven years and graduated from California State University Fullerton with a bachelor of fine arts in painting and drawing in the fall of 2000. Shortly after, I started working at Disney as a scenic artist. As my commercial art career with Disney took off, so did my fine art career. I started showing my own work in galleries in and around Los Angeles, like La Luz de Jesus Gallery and The Corey Helford Gallery. I still work as an artist for Disney and show around the country. Along the way, I have received many illustration jobs through the surf and skateboard industry, like Hurley, Quicksilver, and Grind King. My illustrations have appeared on everything from t-shirts and board shorts to a variety of skateboarding products world wide.

2. I like to use oils on panel when extreme detail is called for in a particular piece. I use very thin layers of paint thinned with medium to create a luminous effect in my work. In my drawings, I like to use a full range of pencils to bring out the form and detail of each subject.

3. I love the drawings of skateboarding illustrator legend Jim Phillips. His illustrations graced thousands of skateboards and stickers for over twenty-five years.

4. I don't like to think my work is directed for any one sector. It could be used for any sector, an editorial in a magazine to a cover of a novel.

5. I see my art expanding even further than it already has. I see both national and international museum exhibitions and more surf and skateboard products featuring my illustrations and paintings.

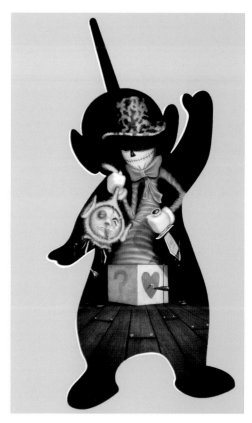

Pop Goes the Evil
Oil on acrylic on canvas on panel.
Private collection.
2006

Chemical Bear
Oil on acrylic on canvas on panel.
Private collection.
2006

Paul Frank is NOT your Friend
Oil on acrylic on canvas on panel.
Private collection.
2005

Amber Alert
Oil on acrylic on canvas on panel.
Collection of the artist.
2003

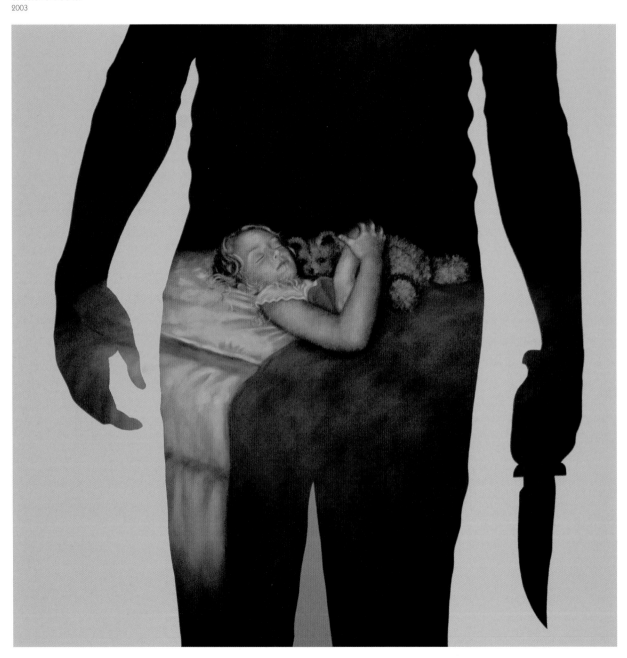

Sugar, Spice and Everything Nice...
Oil on acrylic on canvas on panel.
Private collection.
2004

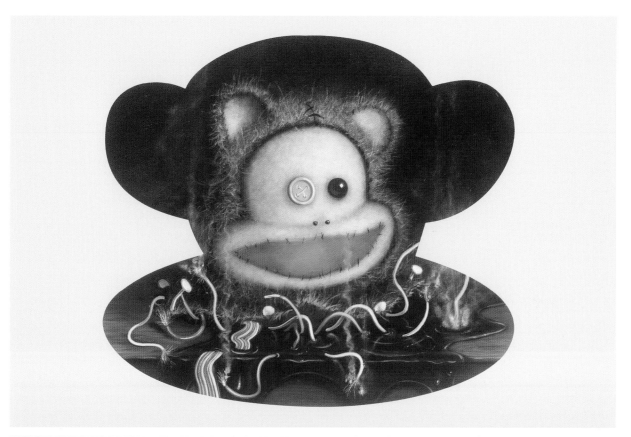

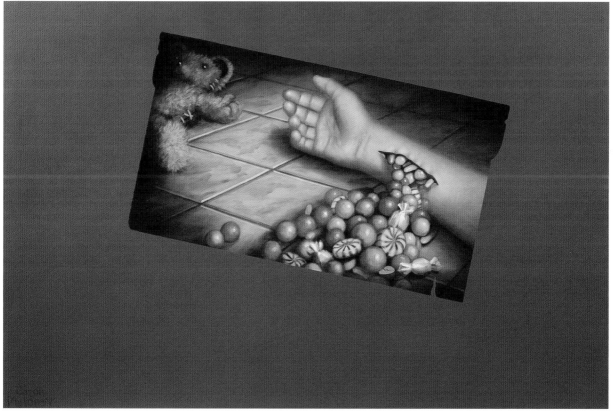

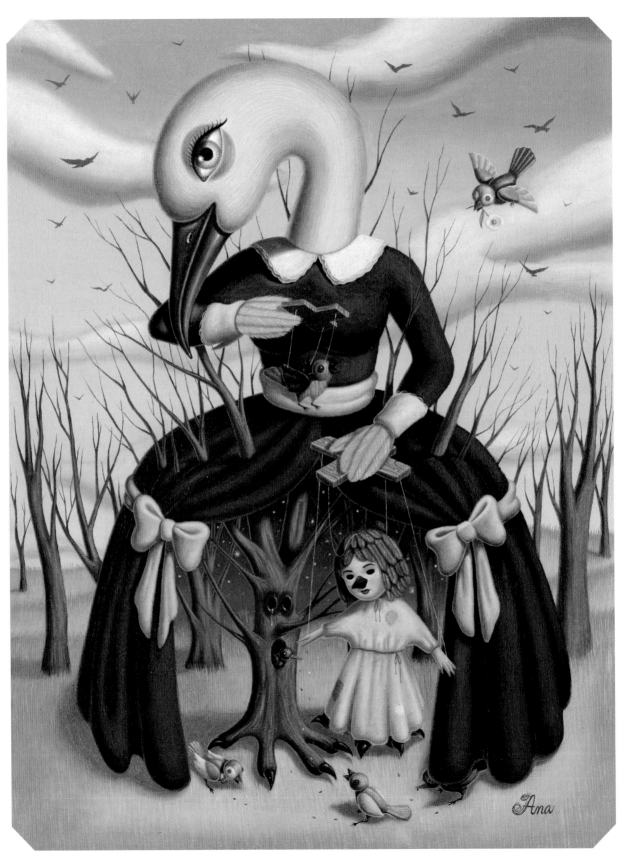

Ana Bagayan

USA www.anabagayan.com anabagayan@gmail.com

All images © Ana Bagayan

1. I don't consider myself an illustrator as much as I do a painter. My fine art and illustration work are very similar.

2. I have learned to paint quickly in the past few years. I don't think there is a secret to painting quickly, you just get faster with time.

3. I've done editorial, advertising, book jackets, CD covers, and so on. I'm open to anything.

4. Still making art.

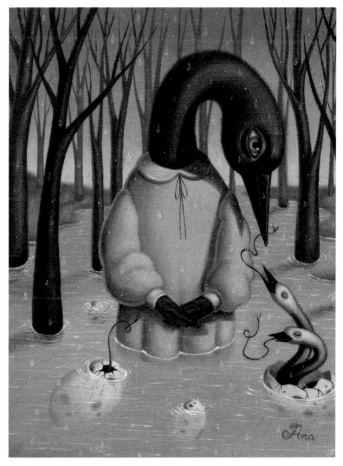

Bird's Brood
Oil on wood panel.
2007

Bird Show
Oil on wood panel.
2007

Rainbow School of Success
Oil on Wood Panel.
2007

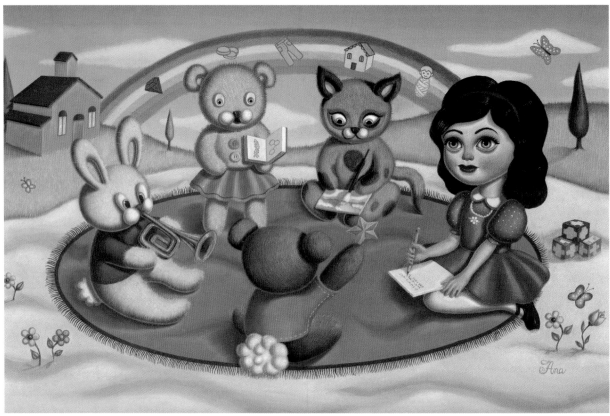

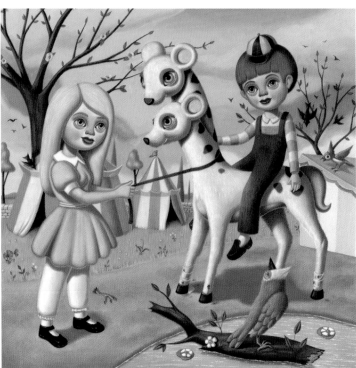

Victorville Carnivàle
Oil on wood panel.
2007

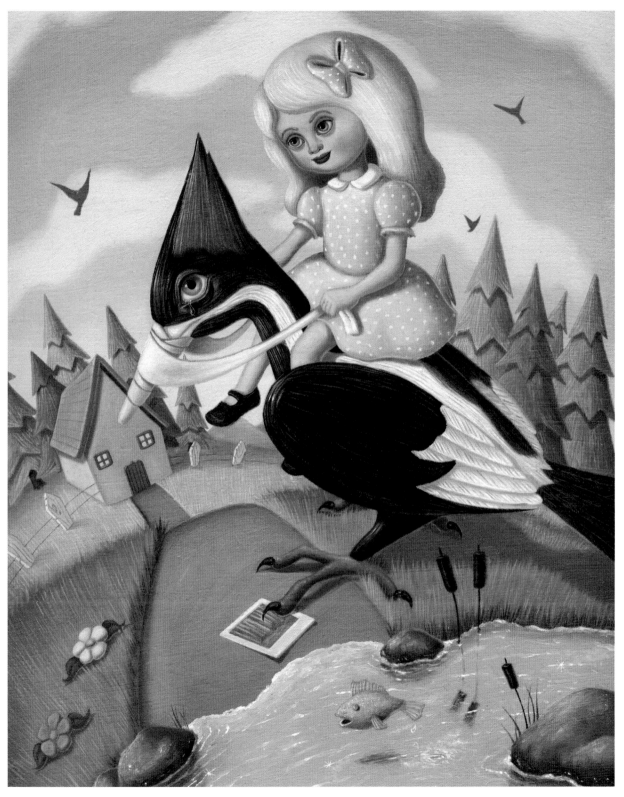

Ivory-Billed Woodpecker
Oil on wood panel.
2007

Page 66/67
Young & Hungry
Oil on wood panel.
2007

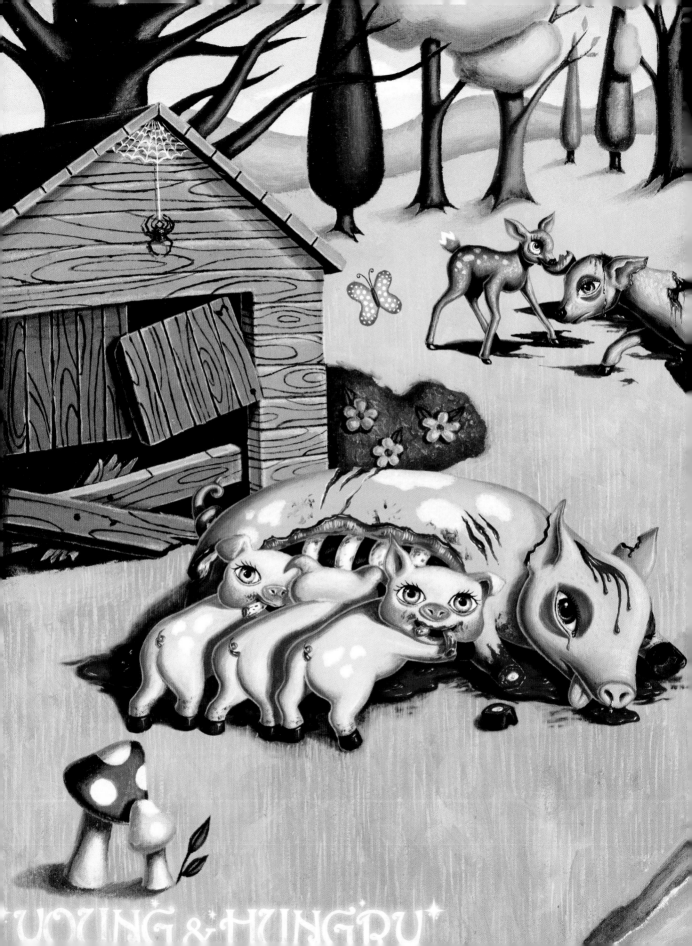

LOVING & HUNGRY

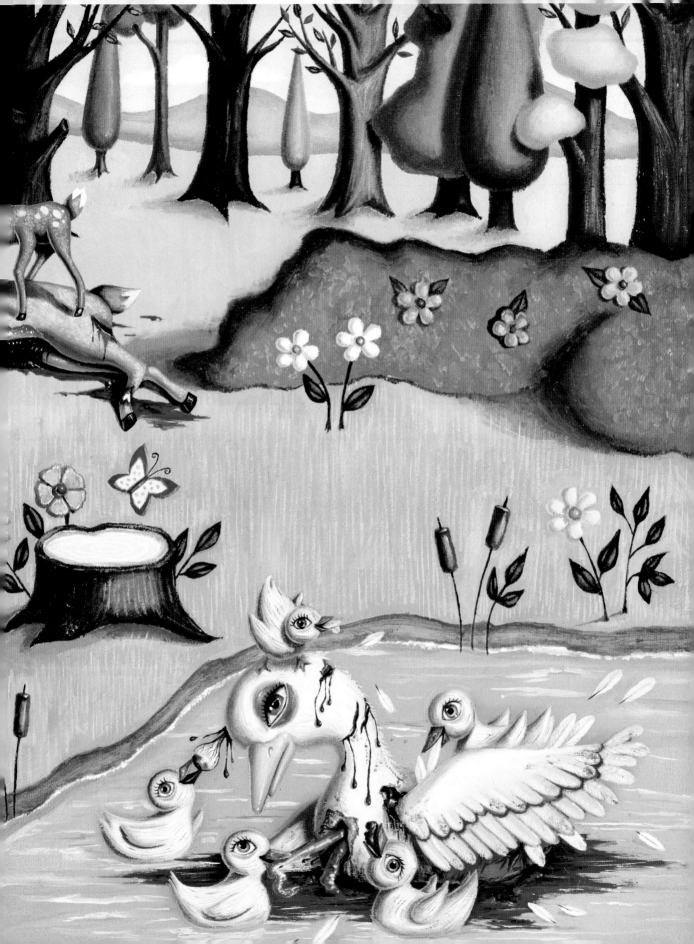

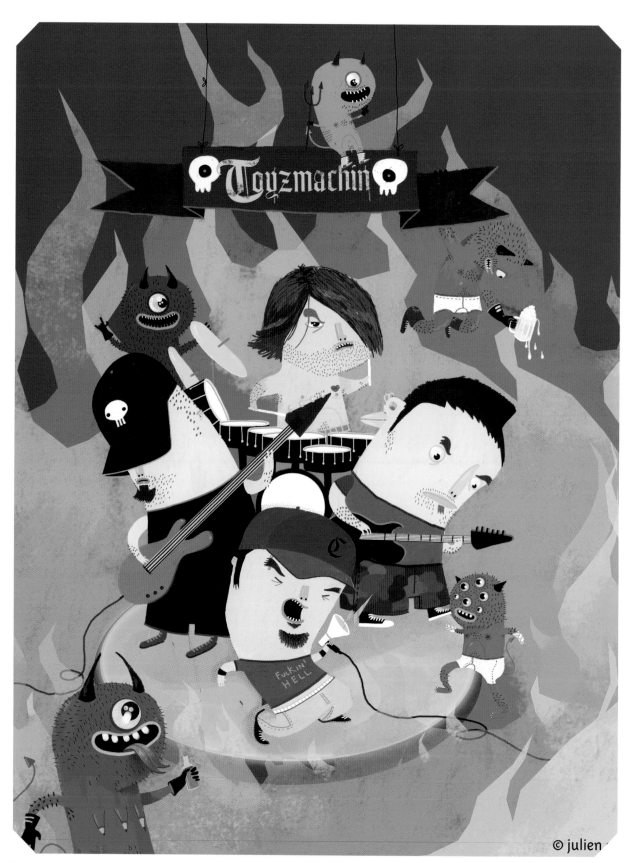

Julien Canavezes

France www.toyzmachin.com djudju@toyzmachin.com

All images © Julien Canavezes

1. When I was a little boy, I drew on my bedroom walls, so becoming a graphic designer/illustrator was an obvious choice. I take my inspirations in everyday life, things like the metro, shops, and Web sites. I take inspiration from everything.

2. First, I draw on a sheet of paper, and then I use Photoshop.

3. I love a lot of illustrators, nevertheless to my mind the best are Dave Mckean, Nicolas de Crécy, Les chats pelés, and Jean-Michel Basquiat.

4. I can work for many sectors, however I admit that advertising and magazines are where I work most.
 I have a French agent which represents me in advertising.

5. In the future, I would like to do character design for cartoons, and even more personal projects. Besides this, I think I will continue working for advertising and magazines of course.

Grrrr
Photoshop.
2007

From Hell
Photoshop.
2007

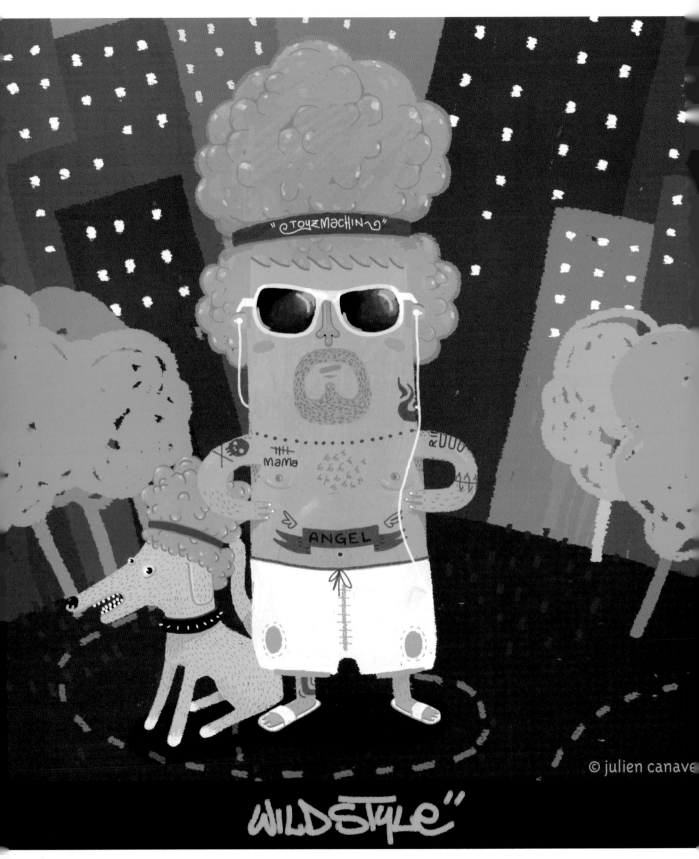

Don't Listen...
Photoshop.
2007

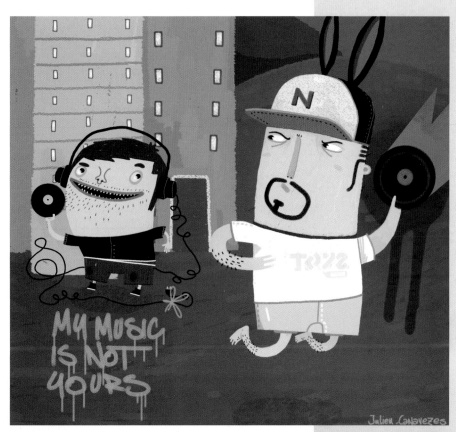

Da Brother yeah yo
Photoshop.
2007

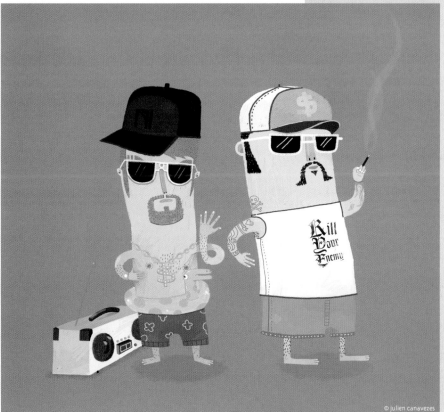

Wildstyle yo!
Photoshop.
2007

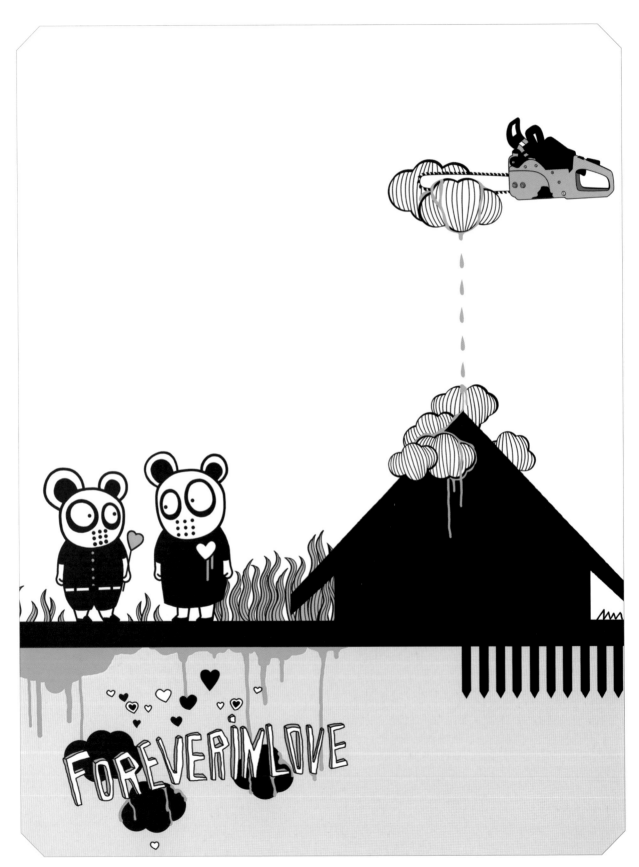

Agentemorillas

Spain www.agentemorillas.com info@agentemorillas.com

All images © Agentemorillas

1. My first calling was to be a surgeon, I finished up by becoming an illustrator around the need to find my true self and be able to express all I couldn't any other way. The inspiration for my work comes directly from my own experiences and my emotions from the life I lead and how it makes me feel.

2. Digitally, I work with a Power Mac G4, Adobe Photoshop and Macromedia FreeHand. Manually I have a leaning towards graphite pencils, felt-tips, and acrylics.

3. I have always felt great admiration for Edward Gorey, who has without doubt left a great impression on me, but I also have come across many other contemporary artists I also respect and admire: Jeremy Ville, Yoshimoto Nara, Nathan Jurevicius, Camille Rose Garcia, Ray Caesar, Tim Burton, Kathie Olivas, Gary Baseman, Ed Templeton, Os Gemeos.

4. I believe one of the most interesting things about my work is its versatility. To be able to adapt to different means without losing my personal touch is a creative challenge as well as an incentive. I imagine the big question must be what attracts the public to my work, but the truth of the matter is I have never stopped to give it a thought.

5.

Completely devoted to telling stories. Drawing, painting, and writing, preparing to launch a book and having an exhibition on hand to release these stories in a way like no other.

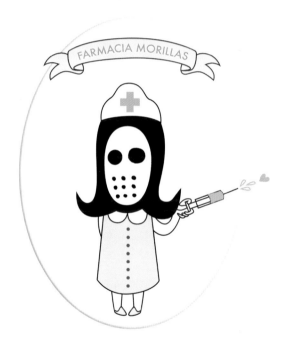

Drugstore Morillas
Power Mac G4, Photoshop, FreeHand.
2007

Foreverinlove
Power Mac G4, Photoshop, FreeHand.
2007

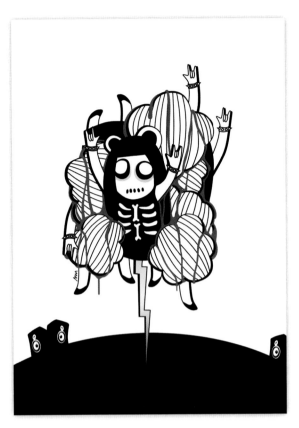

Without title
Power Mac G4, Photoshop, FreeHand.
2007

When it rains you get wet
Power Mac G4, Photoshop, FreeHand.
2007

Catalunya is like that
Power Mac G4, Photoshop, FreeHand.
2007

Tara McPherson

USA www.taramcpherson.com tara@taramcpherson.com

All images © Tara McPherson

1. I think I've always known I wanted to be an artist, and that's why it comes so easy to me. Not saying it's a breeze though, it's a lot of hard work and energy, but to me that's the easy part. I just love what I do. I have freelanced since I graduated college in 2001, and have done a wide variety of illustration jobs as well as gallery shows and toy designs. I think an extremely important aspect in freelancing is to always have a variety of art you can make. For me, I showed in galleries, made rock posters, did advertising illustration, book jackets, made my own art prints and merchandise and more. That way, if one aspect of my freelancing was slow, I had all these other things to fall back on. The combination of doing all those things is what helped my career go so well.

2. I use golden acrylics and Gamblin oils on gessoed birch panels. I paint in layers and love painting details. Also I like the play between rendered and flat, I think that dynamic gives the painting more depth.

3. I love classic artists like Bronzino, Botticelli, Van der Wyden, Caravaggio, Titian, Schiele, Hokusai, Hiroshige, and contemporary artists like John Currin, Katsuya Terada, Yoshitomo Nara, Aya Takano, Mark Ryden, Glenn Barr, Kent Williams, Jeff Soto, and Lori Earley.

4. I have done a lot of advertising illustration, but I am trying to get out of doing so much commercial work and focus on my gallery career. Right now the only thing I am doing is working on my solo shows, which is all new paintings. And slowly painting a comic, which should be done by summer 2008. I still want to make toys and cool merchandise, but am being much more selective about what I pick and where I want my art. In the long term, it's very simple. I just want to paint!

Follow Me
Acrylic.
2006

Snake Charmer
6 Color Serigraph.
2007

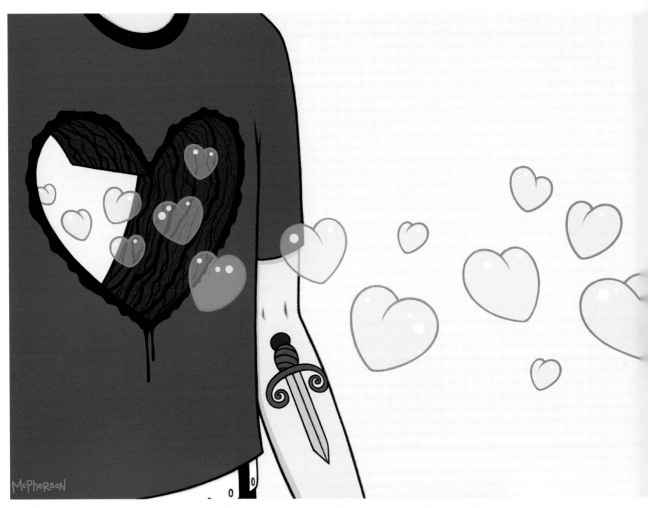

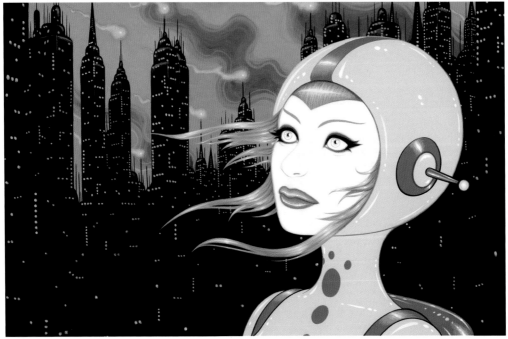

Why Do I Do What I Do
Acrylic.
2005

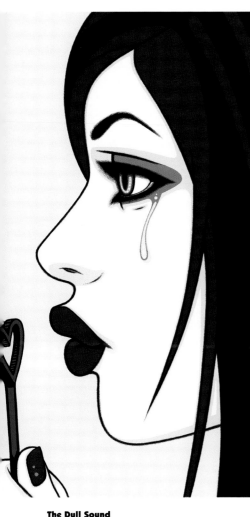

The Dull Sound
14 Color Serigraph.
2005

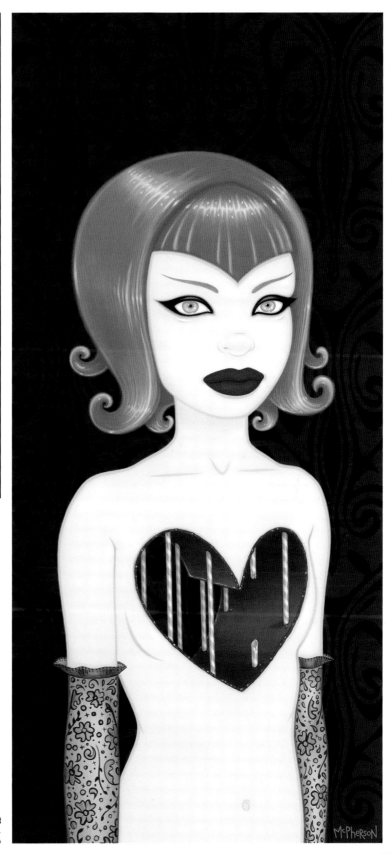

Sometimes I Just Want A Hug
Acrylic.
2006

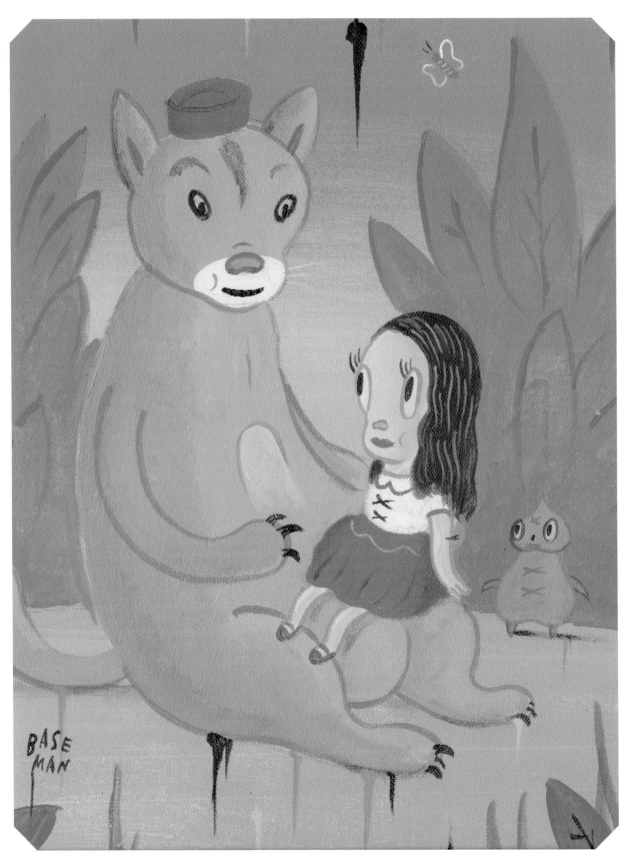

Gary Baseman

USA www.garybaseman.com basemanart@earthlink.net

All images © Gary Baseman

1. To me, an illustrator is being a master visual message maker. Someone hires you with a deadline and a space that needs to be filled, and they give you some kind of thesis or unique selling point, and you come up with a strong visual image that will grab a viewer and bring them into the story. I never studied art formally, but I always wanted to be an artist. I majored in communication studies at UCLA. After I graduated, I put together an art portfolio, not necessarily illustration, and started taking trips to New York to meet with art directors in publications and advertising. I became successful in completing assignments and never looked back. Now, I see myself as a pervasive artist.

2. I personally feel that technique is the least important aspect of art.

3. My inspirations: Man Ray, Walt Disney, Andy Warhol, Charles Addams, Dr. Seuss, Leonard Cohen, Velvet Underground, The Beatles, Jeff Koons, Yoshitomo Nara, David Bowie, Philip Guston, Charles Bukowski, Marcel Dzama, KAWS, and all my wonderful artist friends like Mark Ryden, Rob and Christian Clayton, and Camille Rose García.

4. I don't limit myself to illustration, in fact illustration is only one of many forms of expression my art takes. The definition of pervasive art is that as long as you stay true to your aesthetic and you have a strong message you can put your art on anything. Since being an illustrator I have also created an animated television show, exhibited my paintings around the world at galleries and museums, and produced my own unique products, including vinyl toys and hand bags.

5. My goal is to create a true art company, whereby I create my art and have a staff of designers and producers who take my work and transform it into any medium.

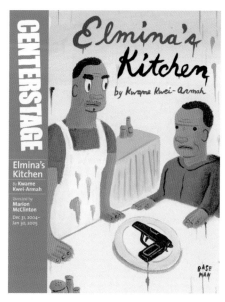

Poster for Center Stage Theatre Company
Acrylic.
2006

Illustration for Cougar Paper Company
Acrylic.
2006

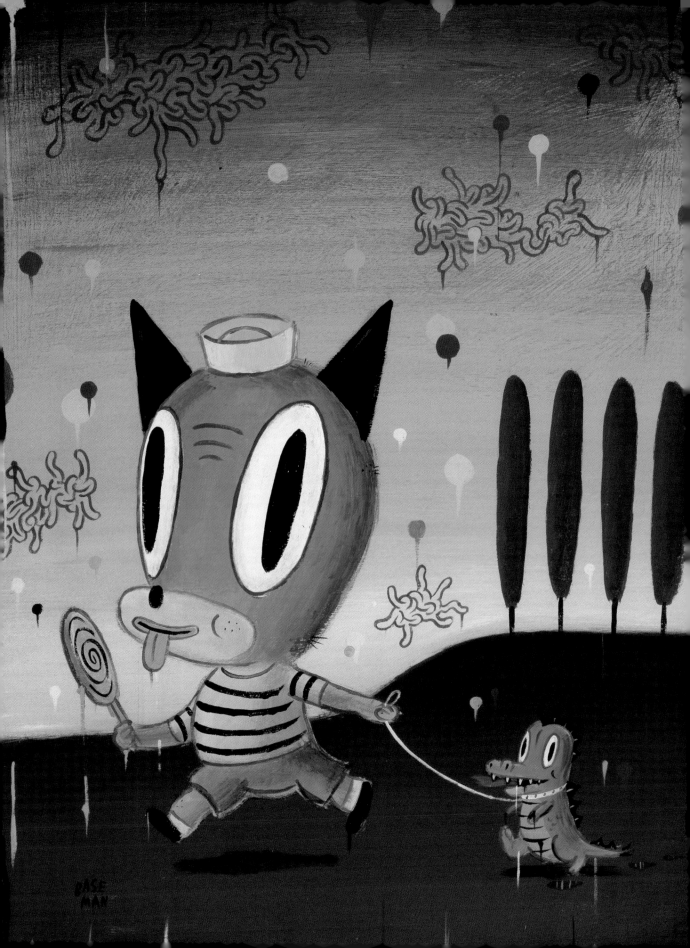

Illustration for Giant Robot Magazine
Acrylic.
2004

Illustration for Toy Box
Acrylic.
2005

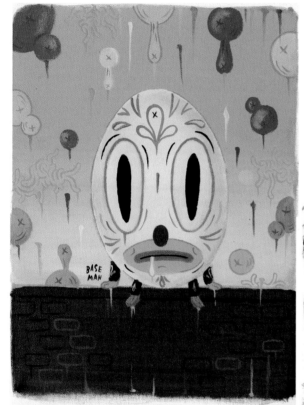

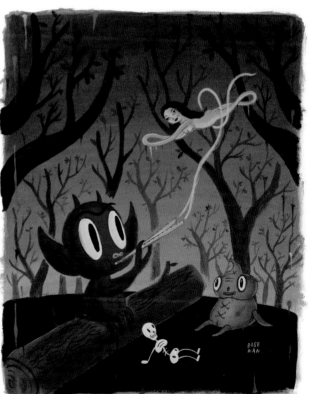

Illustration for Giant Robot Magazine
Acrylic.
2004

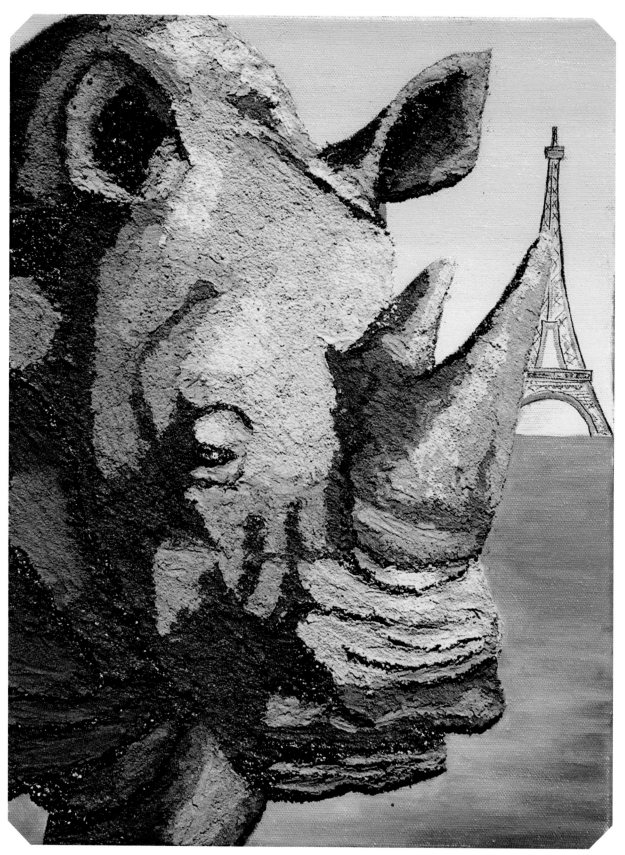

Ilaria Gasperoni

Italy www.myspace.com/ilariagasperoni ilariagasperoni@fastwebnet.it

All images © Ilaria Gasperoni

1. I'm an instinctive and versatile painter. I started painting in 1996 as a self-taught artist when I was living in Brazil for a few years. Before I was most of all a musician, I lived for music, but in Brazil it was the manual and visual expression which came out. I get inspired from nature, which is so lush there and from the people, as creative as nature. In particular, I had a friend who is an Indian woman who made artifacts, statues, and skeps with simple materials, so when I visited her I began to create pitcures, making collages and painting, and using materials like cortexes of the trees, tissues, and other things.

2. I began to create my artwork making 2D and 3D collages using tissues and things I found in the nature like conchs, cortexes, and so on. In Italy, in recent years, I began to use sand too. From 2005 on, I improved my knowledge of painting techniques with various artists like the Danish Anders Pedersen and the Italians Umberto Faini, Giuliana Bellini, and Mintoi. So, my technique now is a synergy between the instinctive 3D and 2D collage using sand, golden leaf, strass, buttons and other things and the classic techniques of painting oil.

3. The artist who I prefer is without any doubt, Kandinsky. I love his painting, and what inspired me most was his book *The spiritual in art*. I took it almost like a bible, and what I try to do is influenced by his concept of inner necessity.

4. My work is directed in every direction, often I work under commission, for example a portrait, or to illustrating books or calendars. Most of all I exhibit at galleries of contemporary art, bistros, and cultural associations.

5. I plan to exibit my artwork, outside Italy someday, like in New York or Barcelona.

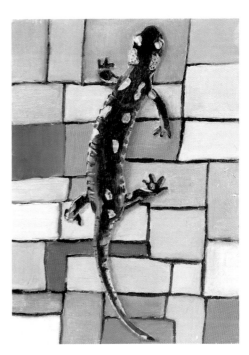

Salamandra
Oil painting.
2005

Rino
Oil painting and sand.
2006

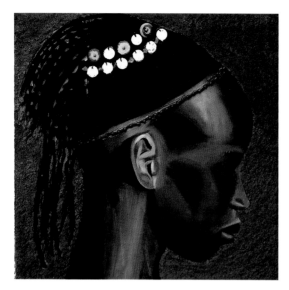

Fulani Girl
Oil painting, 3D collage and sand.
2007

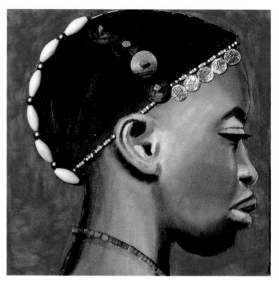

Regina di Saba
Oil painting, 3D collage and sand.
2007

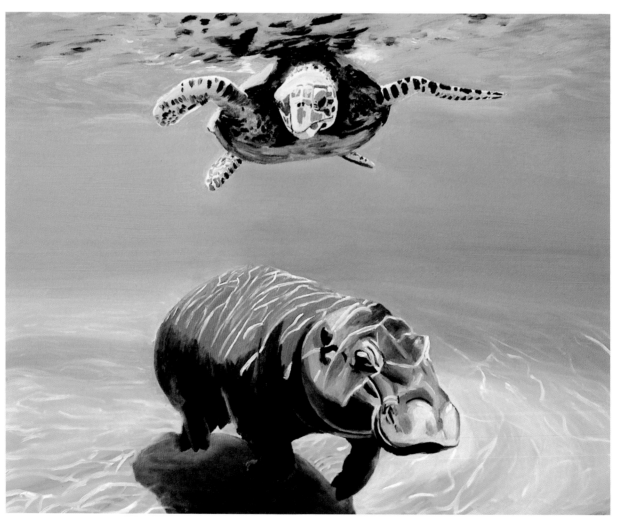

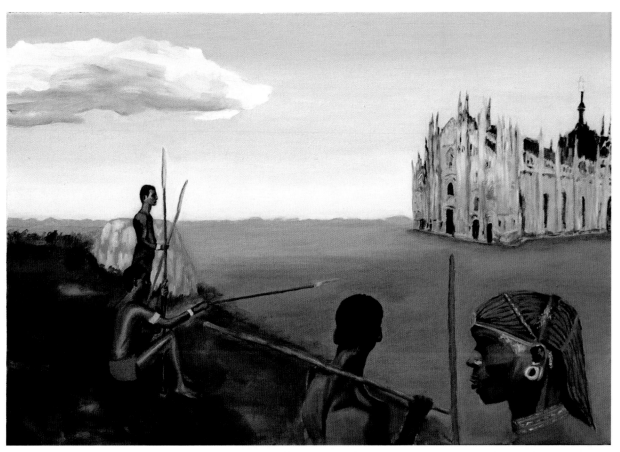

Masai in Piazza Duomo
Oil painting.
2005

Filosofia
Watercolors, oil painting and sand.
2001

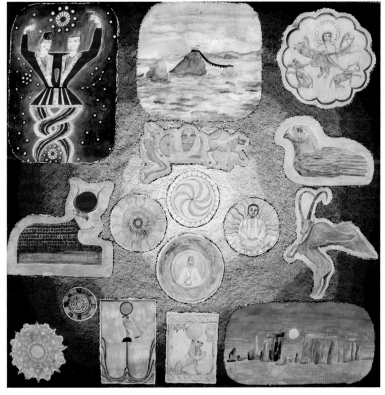

Ippo e Tarta
Oil painting.
2005

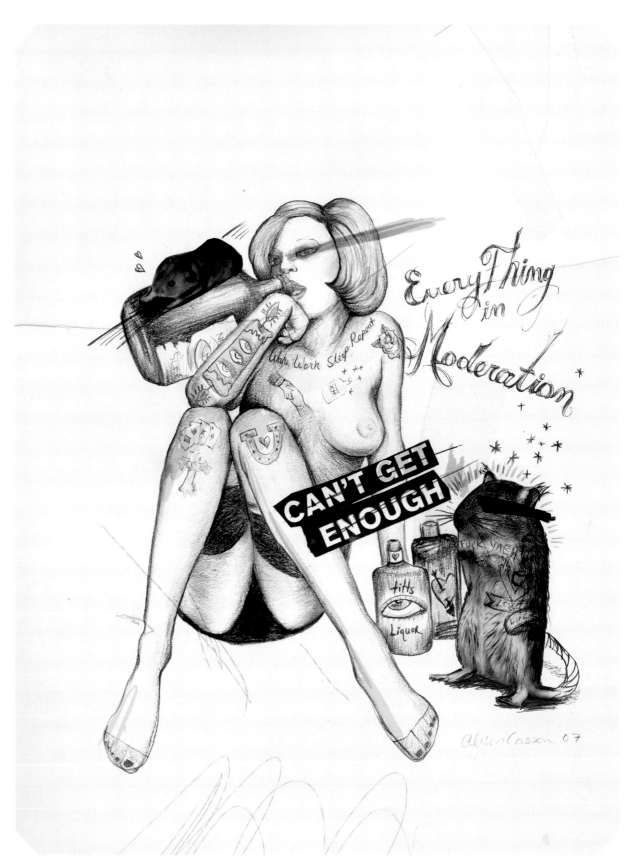

Alison Casson

USA www.alisoncasson.com alisoncasson@yahoo.com

All images © Alison Casson

1. I would describe myself as commmited and excited! Inspired by music and the amazing creative people in the world, whom I feel lucky to call my friends.

2. I love to mix handmade elements with digital. Sometimes I use lyrics as inspiration for imagery. Not such a secret is my insomnia.

3. Mike Giant, Naja Conrad-Hansen/Meannorth, Clayton Brothers, Elizabeth McGrath, Shawn Barber, Liz Lopez, Fafi, Henry Lewis, Jeff Rassier, Gavin Peters, John Paul Altamira, Farroh, Freddie Corbin, Grime Monster, Dax Brunette, Timm Lehi, Tim Hendrix, Jason Kundal, Jeff Soto, Jim Minor, Core Flatmo, Permanent Mark, Norm, Todd Noble, Korin Faught, Martha Rich, Kat Von D, Roxanne Jitomir, Andrew Brandou, Helen Garber, Mark Heggie, Bob Roberts, Rick Walters and Many More!.

4. I see my work mostly in fashion, music, art, popular culture magazines, motorcycle, rock and roll, news, and advertising.

5. I plan to continue drawing and collages with more integration of photography. Create another clothing line. Continue collaborating with other artists I respect.

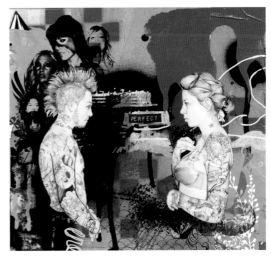

Perfect
Drawing, painting, collage, digital.
2005

Wake Work Sleep Repeat
Pencil, pen, watercolor, collage.
2007

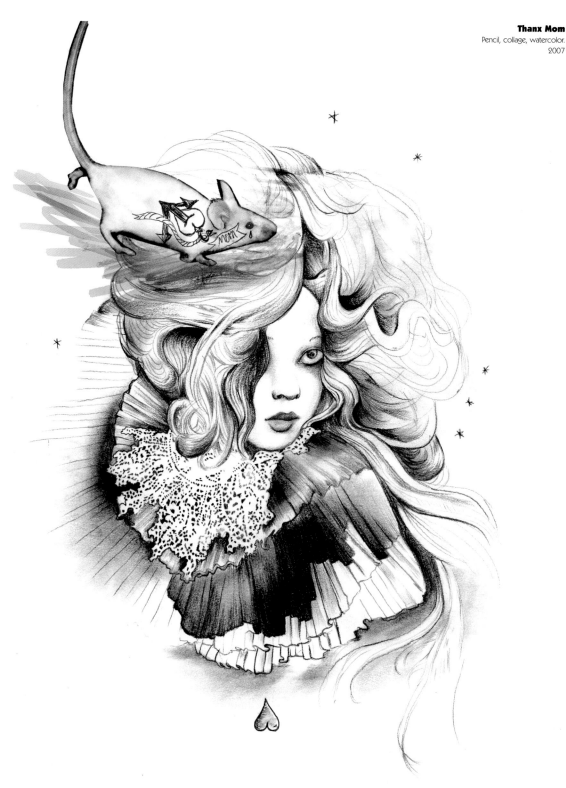

So you say
Pencil, pen, watercolor, collage.
2007

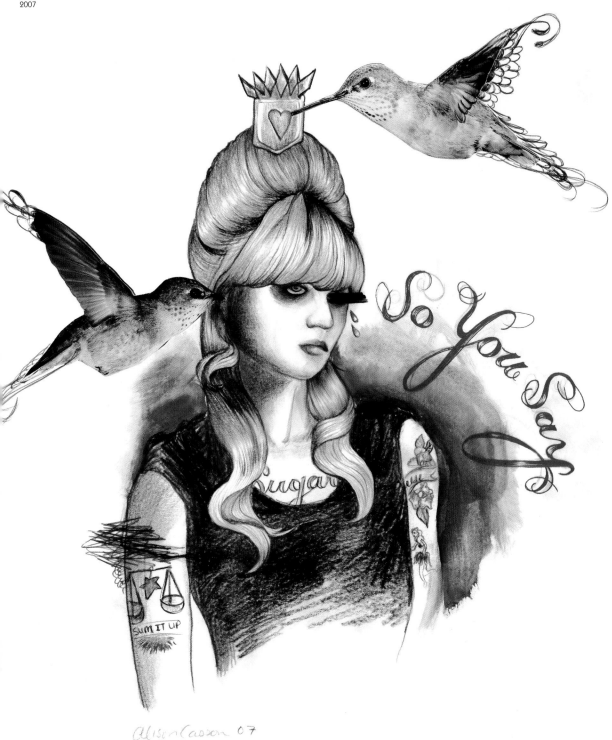

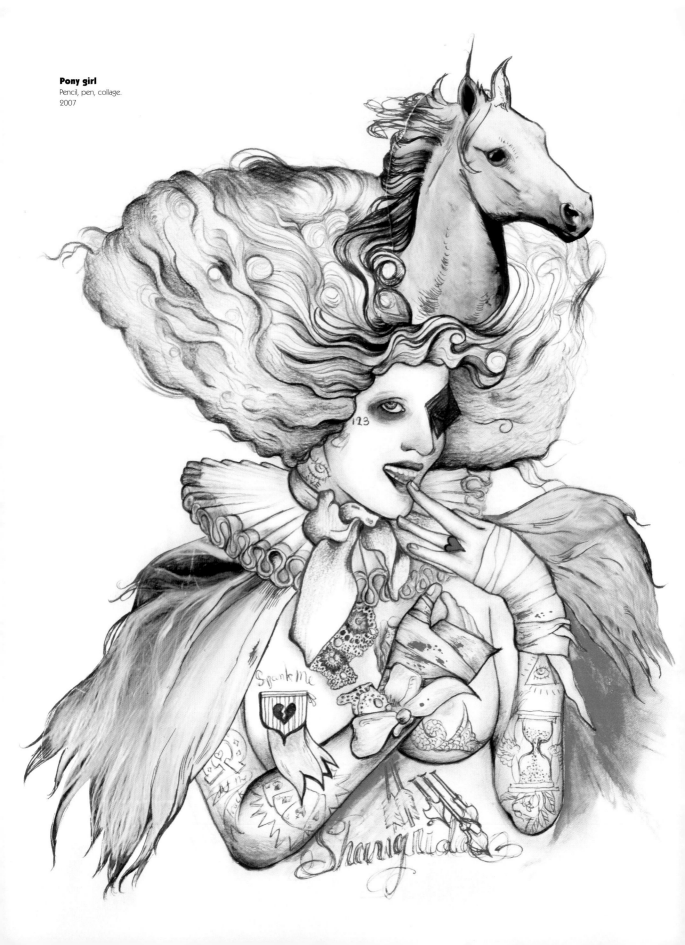

Pony girl
Pencil, pen, collage.
2007

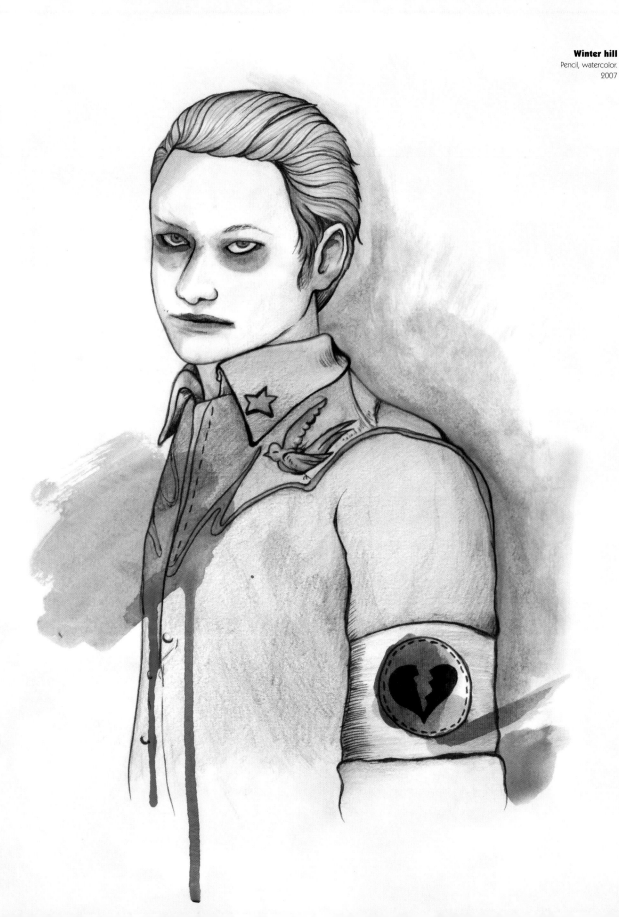

Winter hill
Pencil, watercolor.
2007

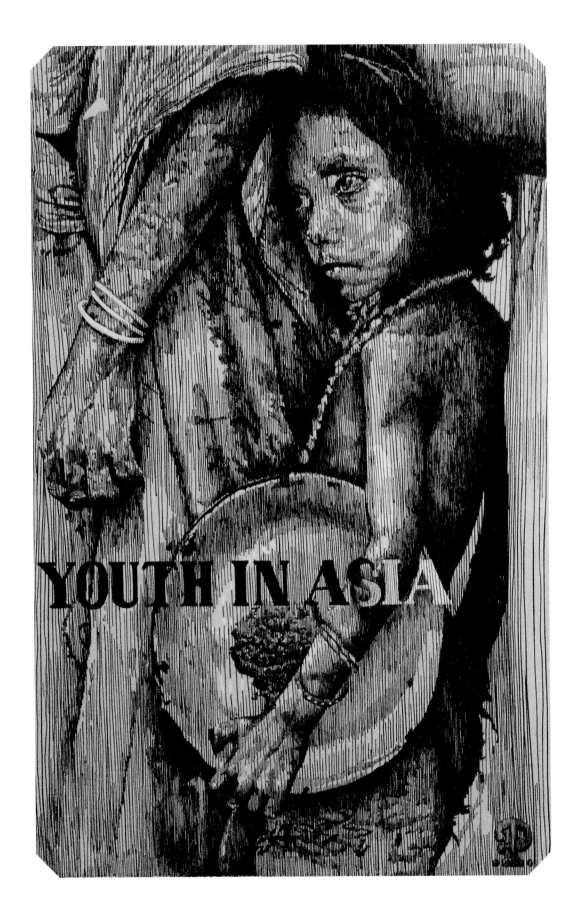

Frank Papandrea

USA www.peninkart.com fpapandrea@gmail.com

All images © Frank Papandrea

1. First I apply the ink using a quill in long vertical strokes. An overall tone is put in place first, then I fill the pencil shapes with more vertical lines to add shadows, without crosshatching. It is similar to watercolor in that the tone is added from light to dark.

2. The trick to clean work is to use a new quill as often as possible, since the nib wears down and is unable to create the incredibly thin lines needed to split the other lines in order to create form and not allow the ink to blot, or touch the other lines. Once I was able to do this without the help of magnifying glasses but my vision has given way to age.

3. My pen and ink illustrations are influenced by Albrecht Dürer's engravings, begin with subjects that matter. A subject must mean something. Artists are mirrors, and our communication method is pictures. I take his inspiration from life and its perverse insanity. Once the appropriate photos for subjects are chosen, I draw the scene in pencil, identifying the light and shadow areas in shapes not unlike topographical drawings.

4. My work is aimed at collectors looking to shake up their collection and magazines willing to go retro and use an illustrator instead of photography.

5. As a creative director for newspapers and magazines in south Florida, I am aware of culture and news, and will always have something to say about something.

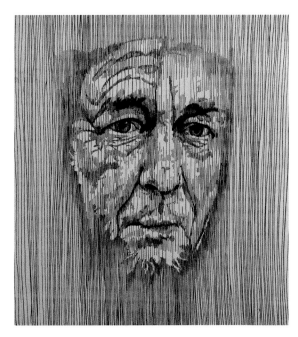

Alexander
Straight engraving.
1978

Youthinasia
Straight engraving.
1979

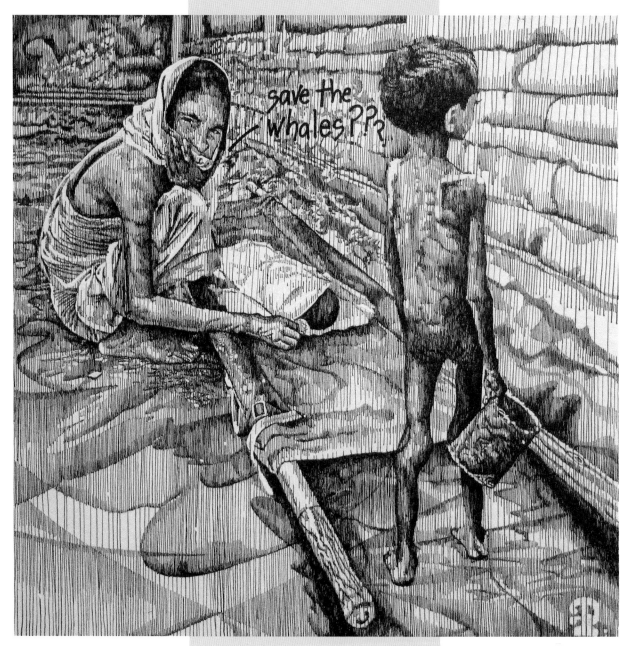

Save the whales?
Straight engraving.
1999

Barbed wire
Straight engraving.
2003

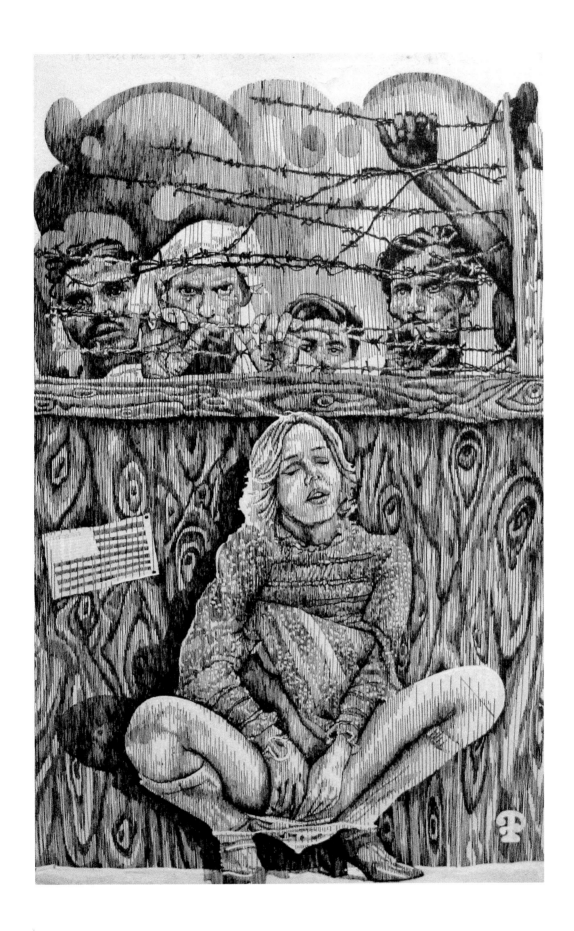

SPANISH SEXY SOUNDS '06

スパニッシュ・ミュージック・ナイト

06.9.6(wed.) at DUO MUSIC EXCHANGE in SHIBUYA

feat. EDWIN MOSES, GECKO TURNER, CYCLE

一夜限りのミュージック・イベント。EDWIN MOSESや
GECKO TURNERによるファンクなソウルサウンドと、
CYCLEによるクールなダンスミュージック。
セクシーなスペインの最新音楽が、ここに集結！

for further details: **www.duomusicexchange.com**

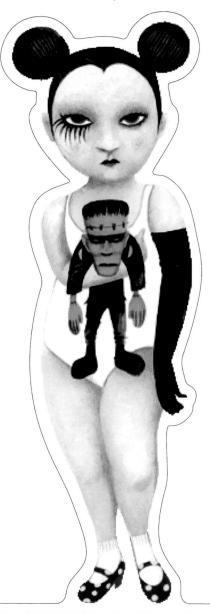

LATIN BEAT FILM FEST '06

第3回スペイン・ラテンアメリカ映画祭

06.9.16(sat.) → 9.22(fri.) at AMUSE CQN in SHIBUYA

最新のスパニッシュ・ムービーを、どこよりもはやく日本初上映！

今、もっともパワフルにカルチャーを発信し続けているスペイン&ラテンアメリカ。
今年も、現地から最新の話題作をピックアップ。この機会をお見逃しなく！

 ▲CONACULTA　後援：朝日新聞社

Official home page: **www.latinbeatfilmfestival.com**

Ana Juan

Spain www.anajuan.net anajuan@anajuan.net

All images © Ana Juan

1. For as long as I remember I have always had a pencil in my hand, doodling everywhere. I adored reading illustrated books, which I imagine is where my passion for illustrating and drawing came from.
 A student of the beaux-arts, I very soon began to work with magazines and newspapers. As an illustrator I have felt as if I were in no man's land, not usually allowing myself to be influenced by trends, to me it seems enough to make a go of my work.

2. I always use acrylic colors and I usually work on paper, although I also like to paint on cardboard or canvas. Collage and wax crayons both appear to me to be very attractive techniques.

3. I don't usually look around me for my inspiration, having always sought my inspiration from afar, from such as the Italian Renaissance period.
 I am very much an individualist in my work, and I don't feel comfortable working with other illustrators, feeling that double the work can cancel themselves out, although I do work with a writer and musician, works which I feel complement and are a credit to each other.

4. I have had many experiences, good and bad, in all fields and, if I had to choose the field in which I believe my work would best progress, it would be the illustrated book.

5. I am just finishing an illustrated book, have an exhibition underway and I'm in the middle of a project in Japan. I don't like to make any long term plans, in fact, anything above six months gives me vertigo, so basically I'm just going to take life as it comes.

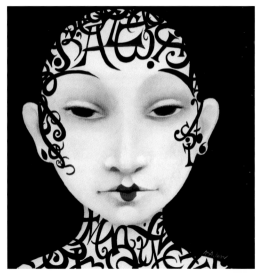

Typobella
Acrylic on paper.
2004

Latin Beat Film Festival
Acrylic on paper.
2006

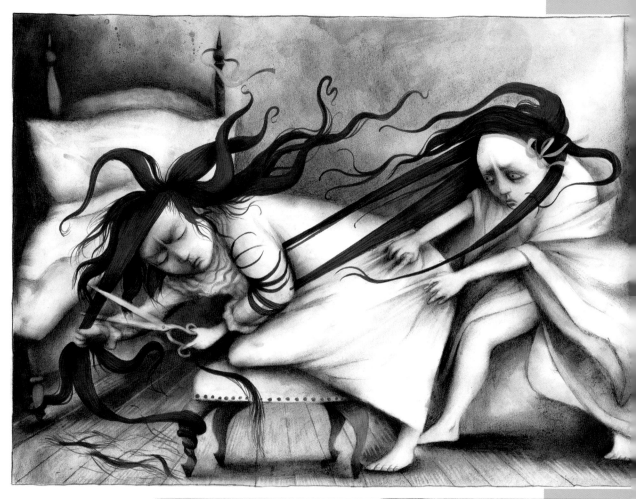

Two Sisters I
Acrylic and charcoal on paper.
2007

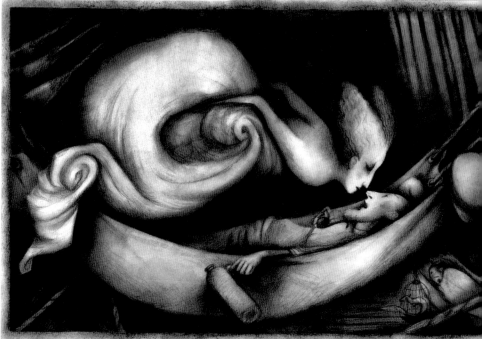

Demeter
Watercolor, pen, and charcoal on paper.
2007

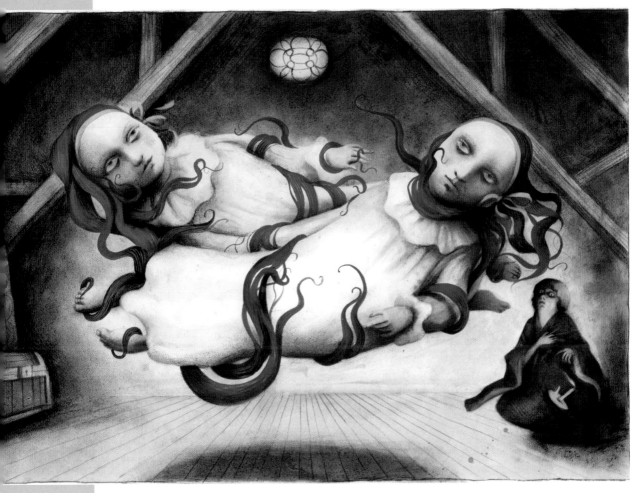

Two Sisters II
Acrylic and charcoal on paper.
2007

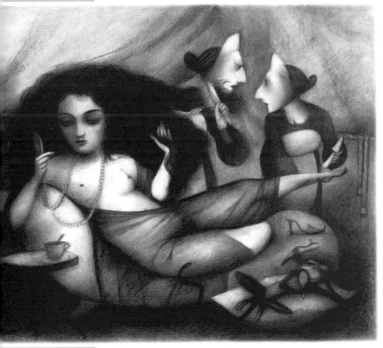

Snowhite
Charcoal on paper.
2001

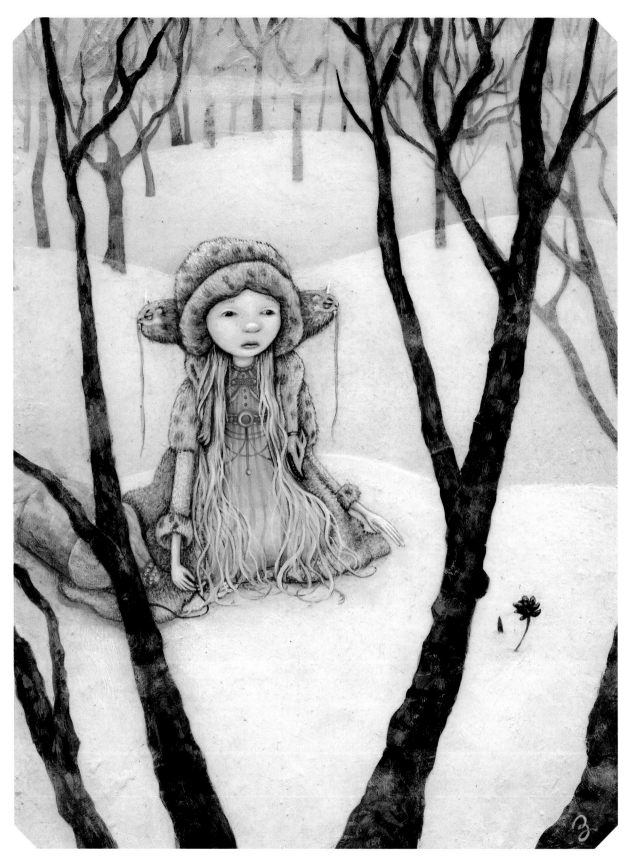

Jaime Zollars

USA www.jaimezollars.com jaime@jaimezollars.com

All images © Jaime Zollars

1. I was inspired to draw by my parents when I was young. They bought me my first black hardcover sketchbook when I was about four years old. I continued to draw throughout my life, and pretty much always assumed I would be an artist when I grew up. I went to art school at The Art Center College of Design in Pasadena, California, and earned a bachelor of fine arts in illustration in 2003. I started working for books and magazines, and whoever would give me a chance pretty soon after that. I've since worked for clients like United Airlines, the Red Cross, Tricycle books, and the *Los Angeles Weekly*, and have also begun showing paintings in several galleries on the west coast.

2. I use collage and acrylic paint for most of my images. Cutting out textures and pieces of found imagery from magazines and found paper to incorporate in my artwork actually makes the image more interesting, and sometimes even saves me time. The edges of the cut pieces are easy to paint around with a clean line, and the textures often show through the paint I put on top.

3. I have a ton of favorite illustrators working today, but I often look to gallery painters and artists outside my genre for inspiration. I mostly look up to historical painters like Bosch and Bruegel, but contemporary artists like Mark Ryden, Joe Sorren, Jonathan Weiner, and comic artist Chris Ware are some folks I admire working today.

4. Right now, I think my art looks most focused on the children's book market, because many of the images look as if they are out fairy tales. I've managed to work in many sectors of the illustration world when the art director is looking for something more imaginative.

5. Right now, I'm trying to pinpoint what exactly I'd like to focus on. My first few years out of school were about taking every job offered to me, and now I'd like to choose a path and excel in a specific field. I'm most interested in working in the children's market and the gallery world. In the next few years I'll probably choose between them.

Hope for the holidays
Collage and scrylic paint.
2006

Winter's Sacrifice
Collage and acrylic paint.
2006

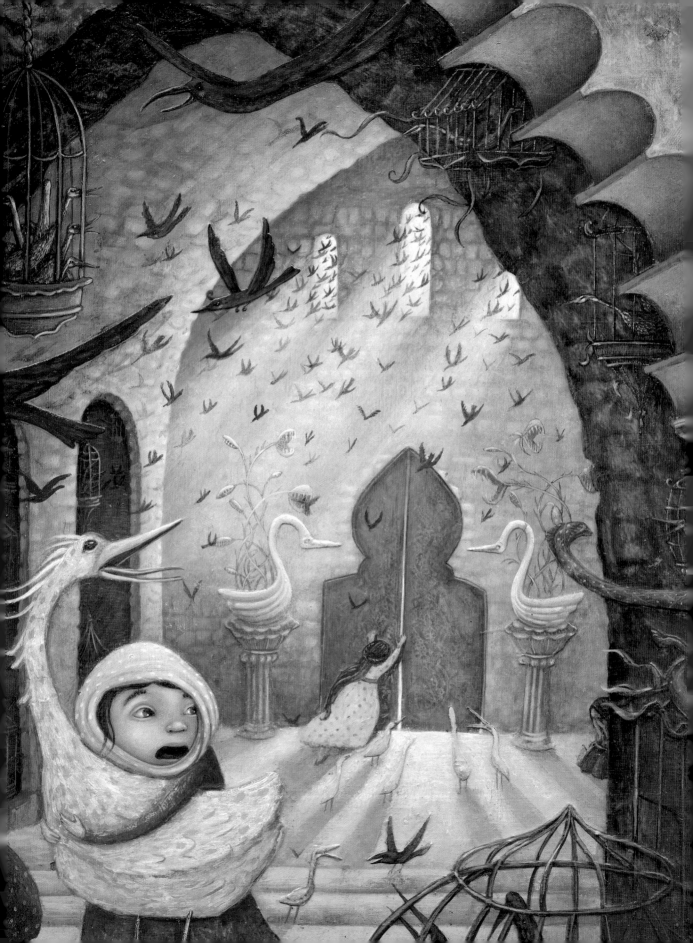

Red Bird Battalion
Collage and scrylic paint.
2006

Sunday Mourning
Collage and scrylic paint.
2007

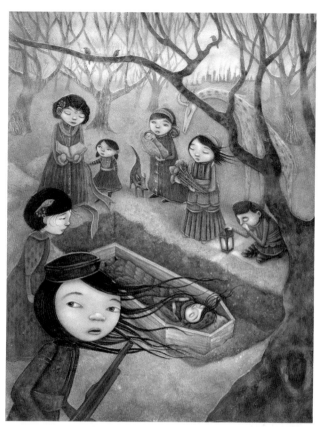

Tengu Graveyard
Collage and scrylic paint.
2007

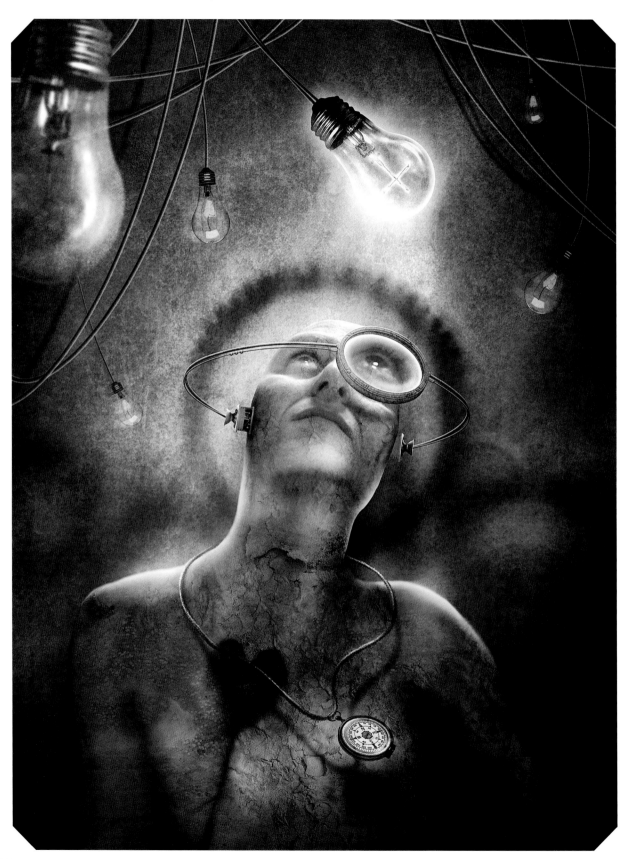

Osvaldo Gonzalez

Argentina www.pixelium-art.com osvaldo@pixelium-art.com

All images © Osvaldo Gonzalez

1. My pieces are visionary illustrations on the human condition that portray scenarios from improbable events, raise questions, and demand the participation of the recipient.

2. I like to mix drawings, photos, and incorporate found objects in my compositions. I always try to give the impression of an old photograph. The digital environment is perfect for reflecting my ideas and making them a reality.

3. I greatly admire the work of Rene Magritte, Salvador Dali, H.R. Giger and Dave McKean.

4. I have found an interesting niche designing book jackets, and science fiction magazines, and CD covers for rock bands.

5. My next project is to complete "Black Boxes," a set of small sculptures I began some time ago.

Exodus
Digital.
2004

Light in the Dark
Digital.
2005

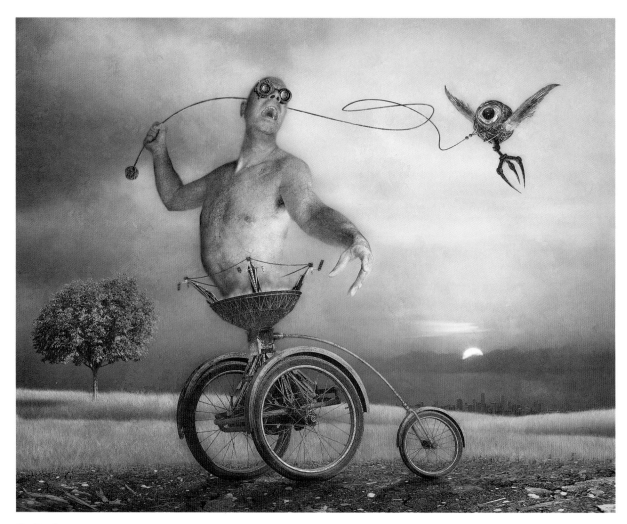

The Watcher
Digital.
2006

Rebirth
Digital.
2003

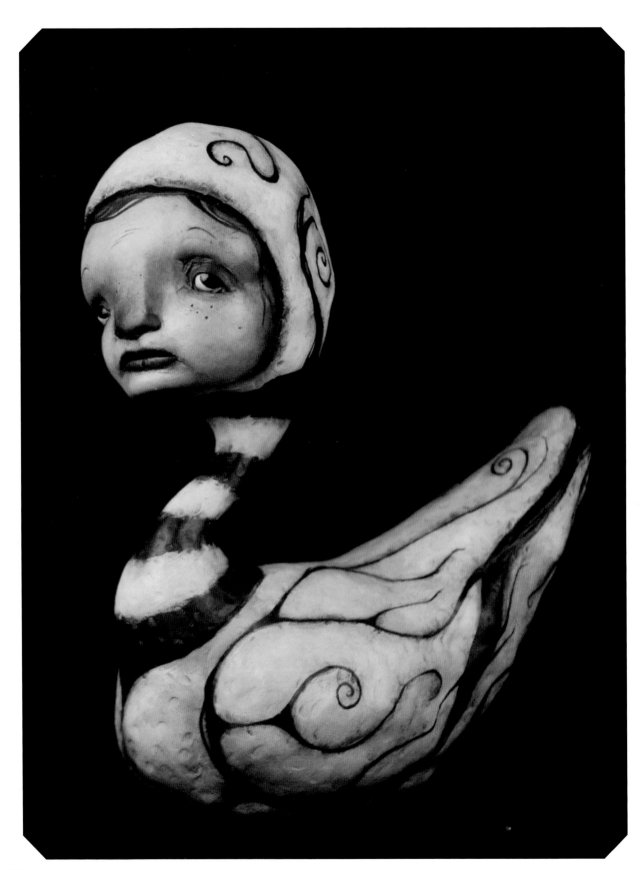

Scott Radke

USA www.scottradke.com scott@scottradke.com

All images © Scott Radke

1. I worked in a factory for nine years and I could see no way out other than through my art. It was very hard to achieve and it's taken me a good ten years. I started making marionettes in 1997. I never really felt a hundred percent comfortable with my 2D work, and sculpture freed me from that. Since then, my work has appeared in several films: *Voices in my Head*, a documentary for the BBC and *Desolation Sound* starring Jennifer Beals, and I created the heads for the band Birthday Massacre's "Blue" video. I was also commissioned to do part of the design at Dela Costa, a restaurant in Chicago. I also work with my wife, choreographer Sarah Morrison and her dance company MorrisonDance. I am very inspired by nature. I don't like to decipher what my work means or is actually saying. I like the viewer to draw his or her own conclusions most of the time.

2. I start by making heads, then I let the heads dictate where I go from there. I will make a set of four to eight heads, then I move onto the armatures. After they are sculpted, I paint. That's usually the most time-consuming part, choosing color schemes, and so on. At different intervals, my subconscious takes over and that's where I feel most comfortable.

3. Maurice Sendak, Joe Sorren, Chris Sickels, John Casey.

4. I am not really sure. I have not received a lot of illustration work for specific projects. My work usually gets incorporated after the fact.

5. More work, more shows.

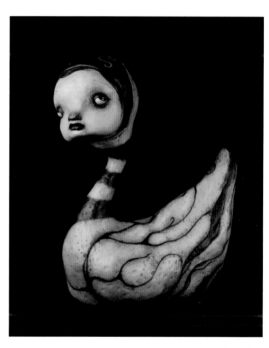

Swan #26
Mixed media.
2007

Swan #23
Mixed media.
2007

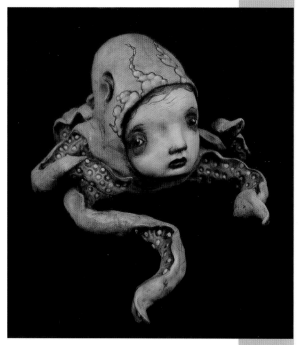

Ocotopus #3
Mixed media.
2007

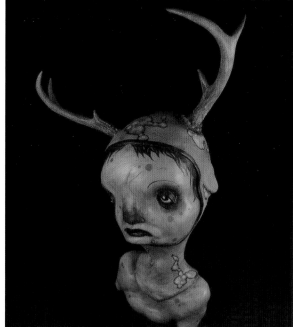

Antlers #1
Mixed media.
2007

Frog
Mixed media.
2007

Face#3
Mixed media.
2007

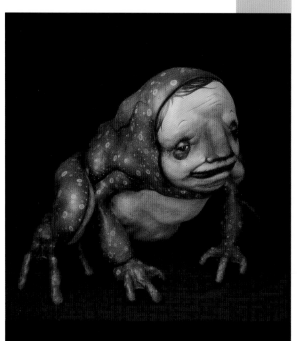

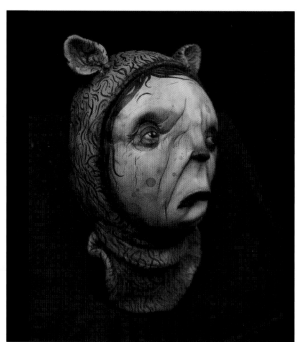

Fish #3
Mixed media.
2007

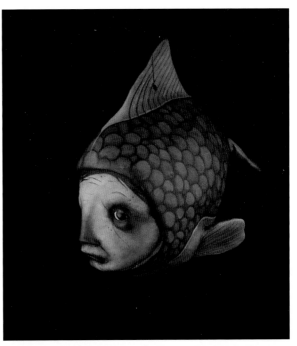

Fish #1
Mixed media.
2007

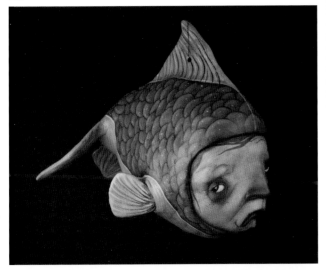

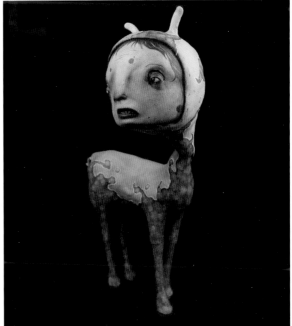

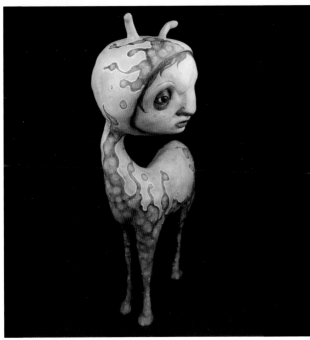

Deer #3
Mixed media.
2007

Deer #4
Mixed media.
2007

Karen Runge

Germany www.mitzebra.de mitzebra@gmx.net

All images © Karen Runge

1. My work was always based on stories. I wanted to tell stories with the things I painted and drew, I wanted to invent my own world with both images and words and I found out that, for me, to work as an illustrator would be perfect. I decided to study illustration in Groningen, The Netherlands and it turned out to be the exactly right place for me. After I completed my studies, I went to Berlin for both inspiration and adventure and to live there as a freelance illustrator.

2. I prefer mixing acrylics, ink, and colored pens with collage elements, sometimes mixed with print techniques, such as woodcut. I like playing and experimenting with different kinds of material and using fabrics and paper that have a meaning to me—for example, pieces of an old dress or a letter or a used bus ticket—things that tell a story.

3. Two illustrators that I think have a big influence on me are the wonderful Edward Gorey and Yoshimoto Nara. I also admire Tove Jansson, whom I loved as a child and whose ironic and poetic style I really appreciate.

4. I think my work is mainly aimed at magazines and books of all kinds, but I can also imagine some of my works in advertising or comics.

5. Future projects of mine involve a short animated movie and plans to extend the production of my stuffed-monster characters. I would like to work on bigger paintings and sculptures—on art that escapes the small paper on the desk and explores the real world. I also have plans for an exhibition with three other illustration artists from Italy and Japan.

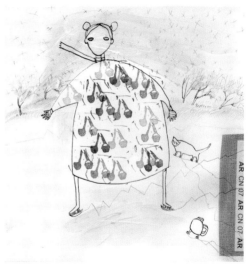

Cherry lady
Acrylic, colored pencil, and stencil.
2006

We're everywhere
Ink on paper.
2007

Strange friends I
Ink on paper and Photoshop.
2006

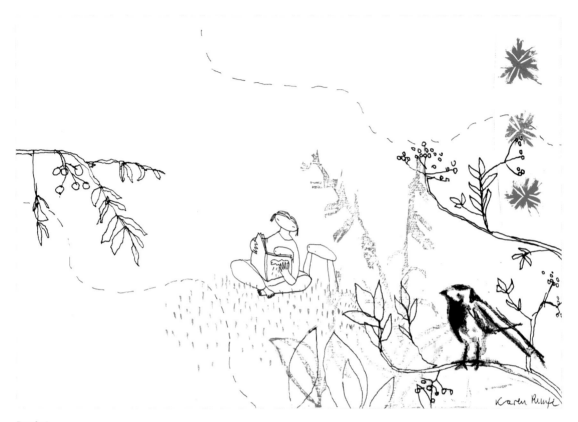

Beetle I
Ink, acrylic, and woodcut.
2007

Treasure
Ink on paper.
2007

Beetle II
Ink, acrylic, and woodcut.
2007

Strange friends II
Ink on paper and Photoshop.
2006

Anthony Lister

USA www.anthonylister.com findmrlister@gmail.com

1. I guess I am more of a painter than an illustrator, as far as definitions go. But I have always drawn. Ever since I was three years old I was fed paper and crayons by my parents and grandparents. I guess that was their way of keeping me out of trouble.

2. I start with a sketch, then begin to paint. I try to not have a too-defined expectation of how the finished piece will come out. I try to let the painting process govern the outcome of the painting more than my idea of how it should be. It's an organic problem-solving process.

3. There are so many. I am aware that I am standing on the shoulders of giants.

4. Homeless people and the mentally impaired.

5. Bigger painting, bigger shows, bigger ideas.

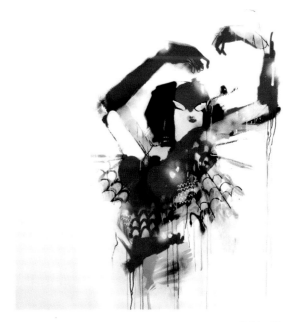

Spider Woman
Ink, enamel, oil paint, acrylic.
2007

Spidey Hanging
Ink, enamel, oil paint, acrylic.
2007

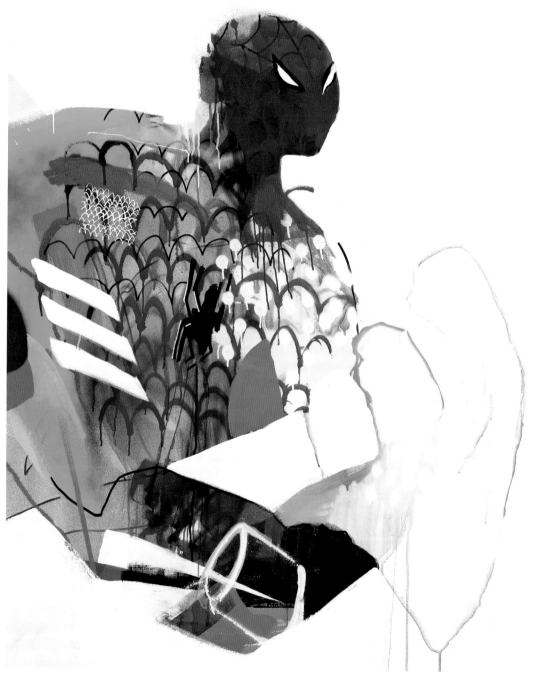

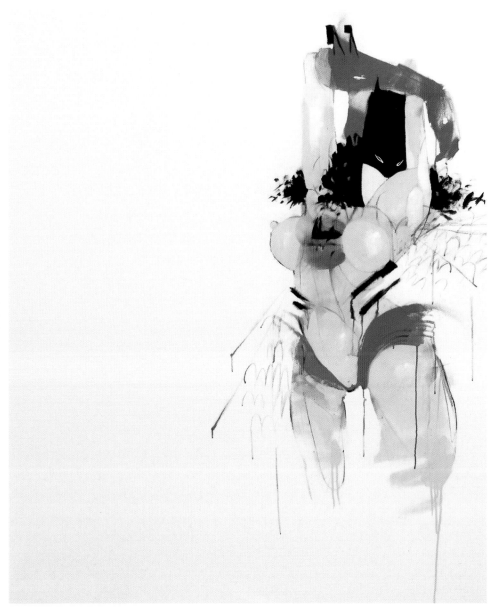

Batgirl With Webs
Ink, enamel, oil paint, acrylic.
2007

Spiderman
Ink, enamel, oil paint, acrylic.
2007

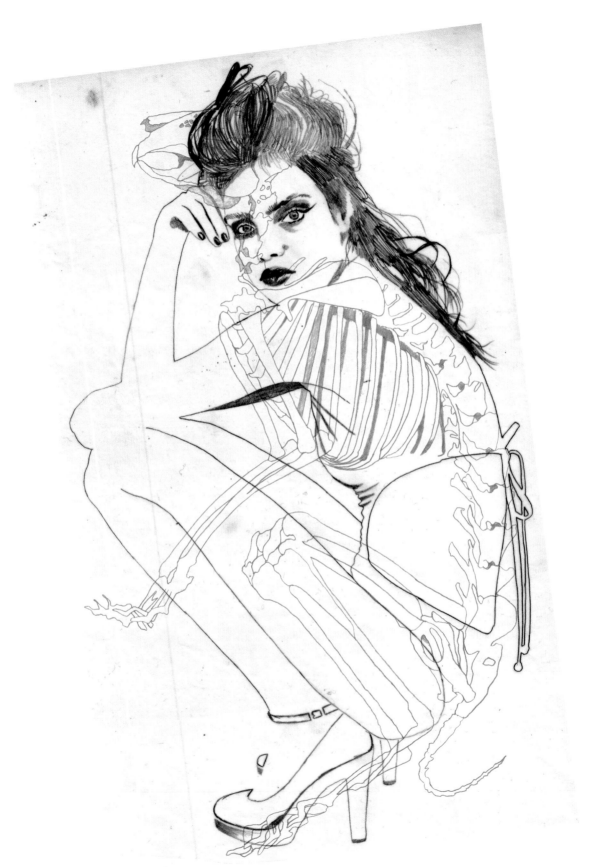

Ros Shiers

UK www.ros-shiers.com ros@ros-shiers.com

All images © Ros Shiers

1. After school, A levels, and art foundation, I attended Brighton University and graduated with first-class honors in 2002. I moved straight to London and set up the clothing label Shiers Sisters with my twin sister. After a stall on Portobello Road Market came Black Pearl Boutique, and finally, a collection for Topshop Boutique marked the end of our collaboration in 2005. I have been working as a freelance illustrator ever since. My illustrations combine burlesque femme fatales with natural imagery: birds, flowers, animal skeletons, and insects, giving them a darkly appealing fantastical edge. My inspirations are the circus, *Alice in Wonderland*, art nouveau, and the dressing-up box.

2. I draw my work by hand, scan it in pieces, then piece it back together in Photoshop, like a puzzle, using the layer tool.

3. Artists that inspire me are Andy Warhol, David La Chapelle, Basquiat, and Banksy plus many fashion photograhers. I adore Julie Verhoeven's work.

4. I have produced editorial art for magazines (*Lula*, *125*, *Cent*, *Russian Glamour*, *ES*) advertising (Ford, Wint & Kidd) and book jackets (John Murray Publishing, Hodder & Stoughton).

5. I'd love to see my work applied to a variety of products. Creating and manufacturing a range of wallpapers would be a dream, designing fabrics for a fashion house, window displays. I would love to collaborate with Agent Provocateur. I will be exhibiting in Topshop (Oxford Circus) next year and would love to plan another exhibition in London.

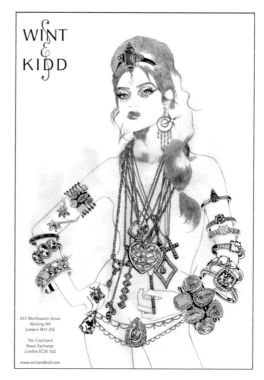

Wint & Kidd
Pencil drawing, photographs and Photoshop.
Ad for bespoke diamond jeweller Wint & Kidd.
2007

Rabbit Skeleton
Pencil drawings, layers pieced together in Photoshop.
Personal work.
2005

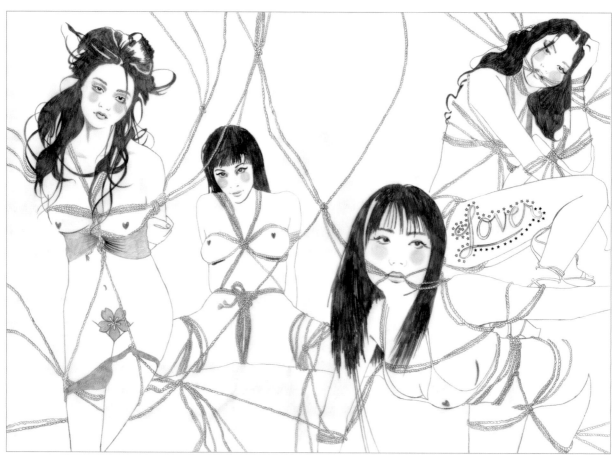

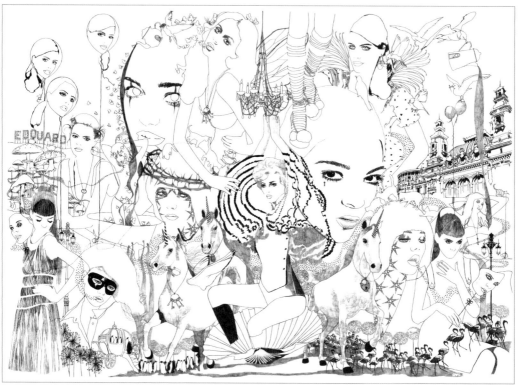

Kinabu
Pencil, pen, and Photoshop.
Illustration for 125 magazine.
2007

Scissor Sister
Pencil and Photoshop.
Personal work.
2007

Leopard Lady
Fineliner pen and Photoshop.
Print design for clothing label Shiers Sisters.
2005

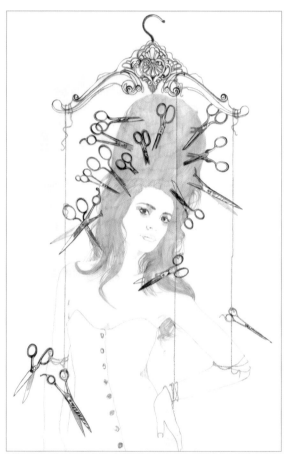

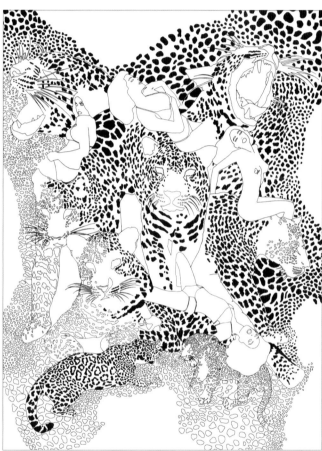

Wonderland
Pencil drawing scanned, Photoshop and pieced together.
Private commission.
2006

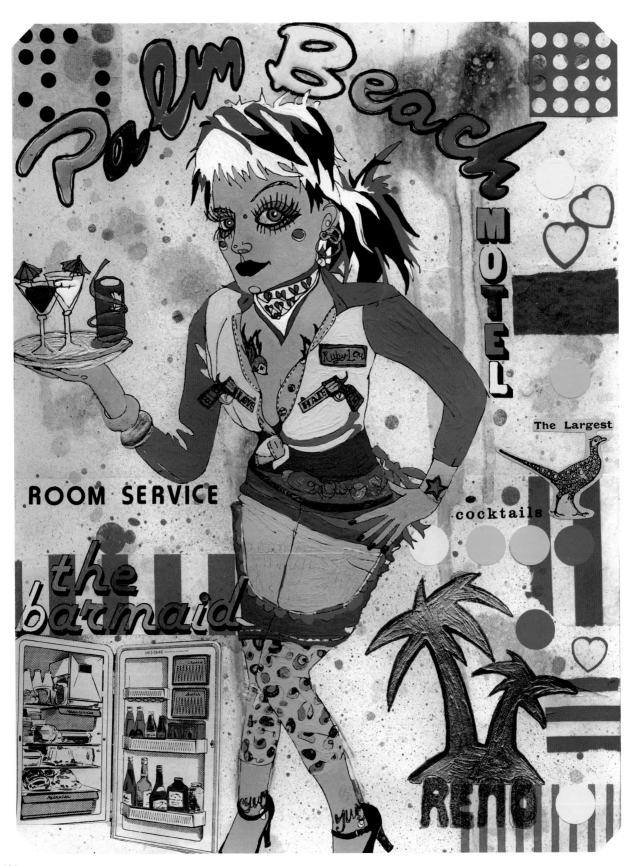

Sarah Beetson

Australia www.myspace.com/sarahbeetson sarahbeetson@gmail.com

All images © Sarah Beetson

1. My paintings and personal illustrations are preocupied with recurrent themes of gender and gender-bending, the subversion and manipulation of sexual roles and identities, drag queens, transsexuals, and gay and lesbian subculture. I have also been increasingly delving into both Australian and global political issues. The darker face of fashion is another element, surfacing in personal identity, eating disorders, and body image. I attempt to portray my subjects in a manner which is nonconformist to society-imposed stereotypes and persistently twists and subverts the preconceptions of popular consciousness.

2. I work by hand using a wide and exhaustive range of mixed media collage elements including gel pens, acrylic, gouache and watercolor paint, spray paint, markers, tissue paper, stickers, buttons, packaging, sweeties, and so on. I render my illustrations on wood, paper, or onto photographic prints if I am combining an illustration with photography. I then scan and deliver artwork for print. I only work digitally when making tweaks and changes to a commissioned piece.

3. My all-time favorite artists and illustrators are: Tomer Hanuka, Yuko Shimizu, Julie Verhoeven, Yoshitomo Nara, Keith Haring, Jose Guadalupe Posada, Del Katherine Barton, Montana Forbes, Britt Spencer, Michael Thompson. The list continues!

4. My work tends to be fashion and figure-based, and most of my clients are editorial, advertising and publishing based. I also do quite a lot of food-themed work–yummy!

5. I am working on another solo show coming up in Australia in the new year, which will be titled "20 Bucks: Bring On The Sluts." I am developing a style for children's books. I am currently designing a childrenswear collection for a European/U.S-based company, which is the first time I have done any fashion design professionally. In the future, I would like to exhibit worldwide, particulary in Japan and New York or Los Angeles.

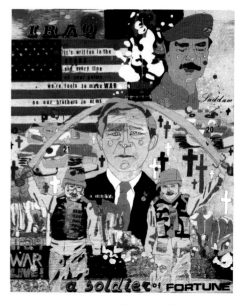

Iraq - A soldier of Fortune
Mixed media collage on wood.
Commissioned by *Yellow Rat Bastard* magazine, New York.
2005

Palm Beach Motel
Mixed media collage on paper.
2006

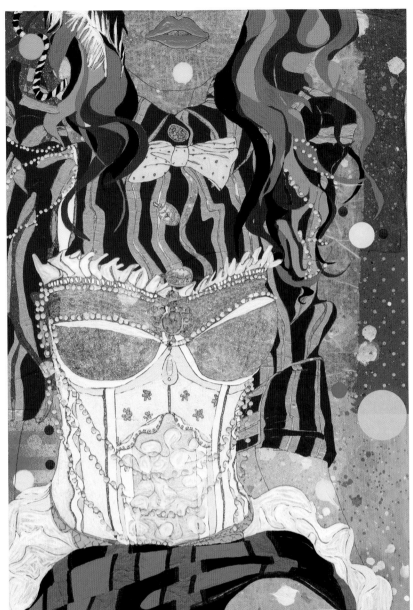

Satya James striped shirt and corset
Mixed media collage on wood.
Commissioned by Fashion Monitor magazine, London.
2007

The Mink Stole
Mixed media collage on wood.
Personal piece focusing on 1960s fashion and film.
2005

Royal Ascot
Mixed media on paper
Commissioned by Delta Airlines magazine, U.S.A.
2007

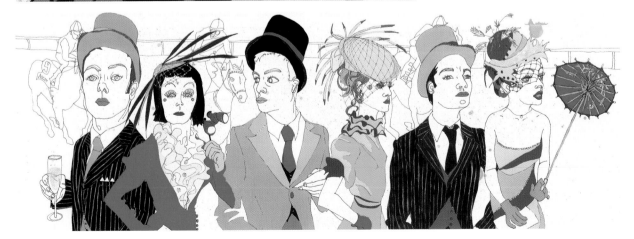

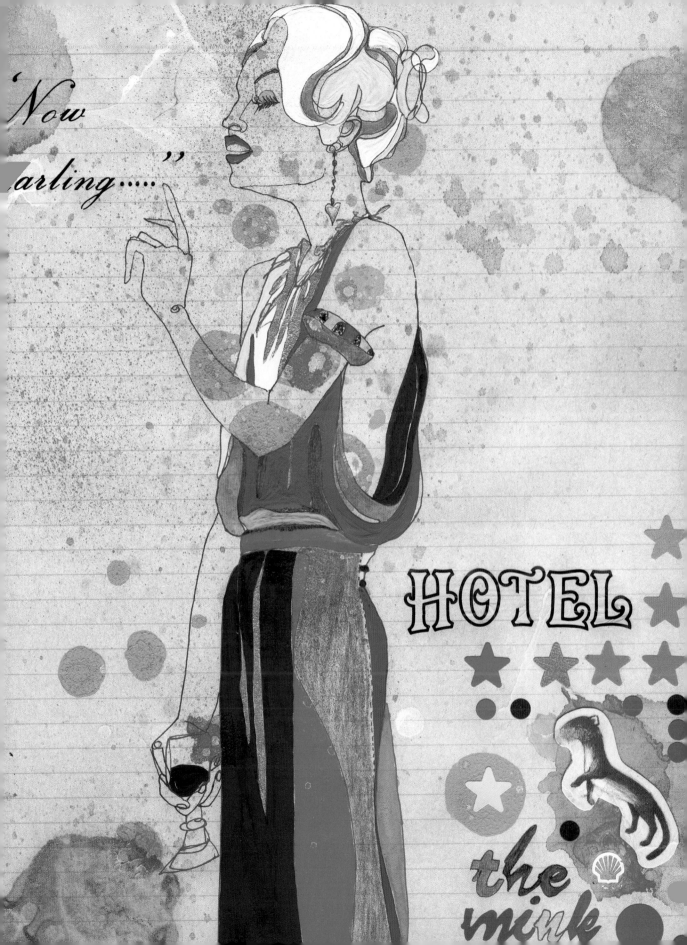

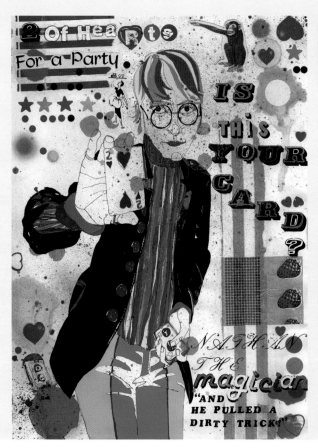

Nathan The Magician
Mixed media on paper.
Commissioned by *The Critical Friend* magazine, London.
2005

Pete Doherty
Mixed media collage on wood.
Personal piece from a celebrity
series following the Live 8 concerts.
2005

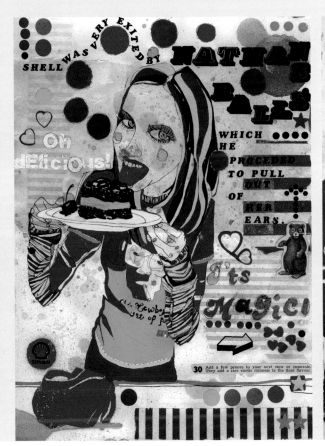

Shell - Oh Delicious
Mixed media collage on paper.
Commissioned by *The Critical Friend*
magazine, London.
2005

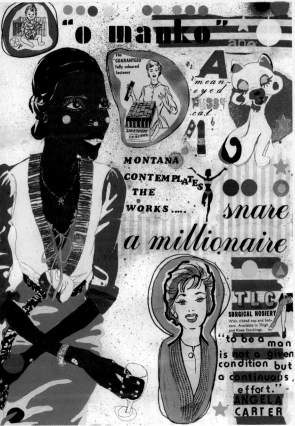

Montana - O Manko
Mixed media collage on paper.
Commissioned by *The Critical Friend* magazine, London.
2005

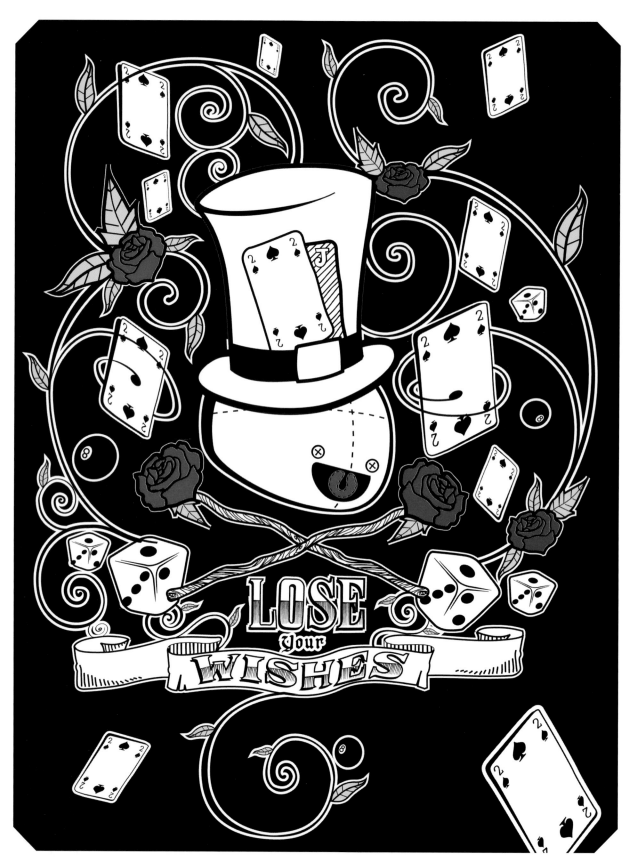

Blue and Joy

Italy www.blueandjoy.com fabio@blueandjoy.com

1. It all began purely by chance one rainy night in Milan. It was there that Blue and Joy were born and that same night the first comic strip was created.

2. We begin by tracing the drawings by hand on paper, which we then convert to vector graphics.
 We have also done animation and canvas paintings and we like to experiment with different techniques in our work.

3. Alfonse Mucha, WK Interact, Caravaggio.

4. In editorials, comics, art journals, merchandising.

5. We want to make our way through exhibitions in and out of Europe, perhaps in the United States.

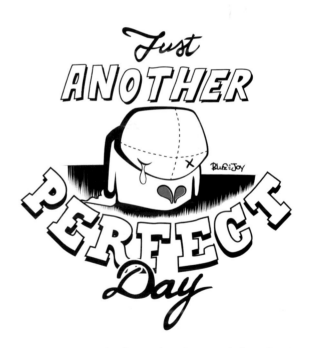

The discouraging adventures of Blue and Joy 2
Vectorial, acrylics, stickers, animation.
2007

The discouraging adventures of Blue and Joy 1
Vectorial, acrylics, stickers, animation.
2007

The discouraging adventures of Blue and Joy 3
Vectorial, acrylics, stickers, animation.
2007

The discouraging adventures of Blue and Joy 4
Vectorial, acrylics, stickers, animation.
2007

The discouraging adventures of Blue and Joy 5
Vectorial, acrylics, stickers, animation.
2007

Tansy Myer

USA www.tansymyer.com info@tansymyer.com

All images © Tansy Myer

1. I was born and raised in Venice, California and grew up in the eclectic artist community of the Venice boardwalk. Immersed in this strange and inspiring world, being an artist has been my way of life. In my work, I explore the social constructs we use to define beauty and self. I am influenced by color, fashion, what's going on in my life and in the world. I received my BFA from UCLA and also attended Goldsmiths College in London. My work can be seen in campaigns for fashion, advertising, and entertainment clientele.

2. Each piece starts out as a pencil drawing and is finished digitally. A great deal of my work is entirely vector in format.

3. Two of my favorite artists are Lisa Yuskavage and Egon Schiele. Their work is very inspiring–their use of color and how they approach drawing the human body is incredible.

4. My work is versatile and I have been fortunate to work with a diverse range of clients. I am excited to keep on finding new formats for my work.

5. I look forward to designing my own line of products, branching into fashion, and continuing to create and show my work.

Ghost
Pencil drawing, digitally colored.
2006

Toothhead Girl
Pencil drawing, digitally colored.
2007

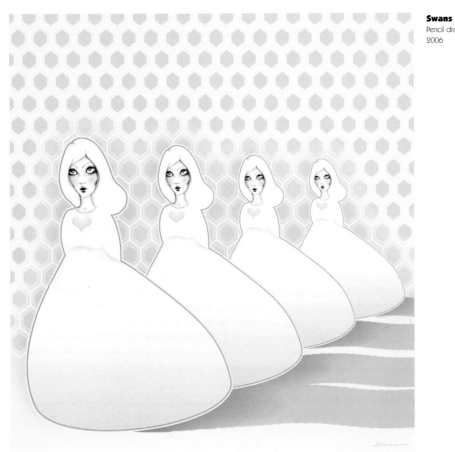

Swans
Pencil drawing, digitally colored.
2006

Pink Mushroom Girls
Pencil drawing, digitally colored.
2006

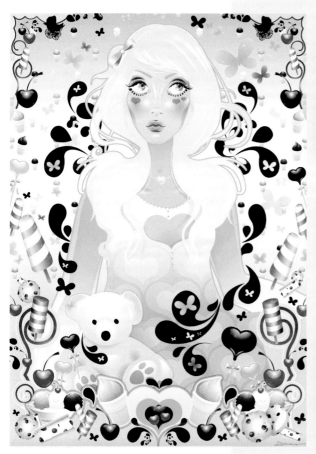

Baby Girl
Pencil drawing, digitally colored.
2007

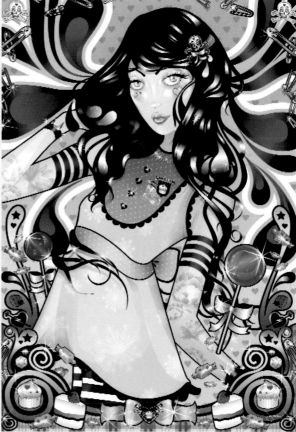

Punk Princess in Candyland
Pencil drawing, digitally colored.
2007

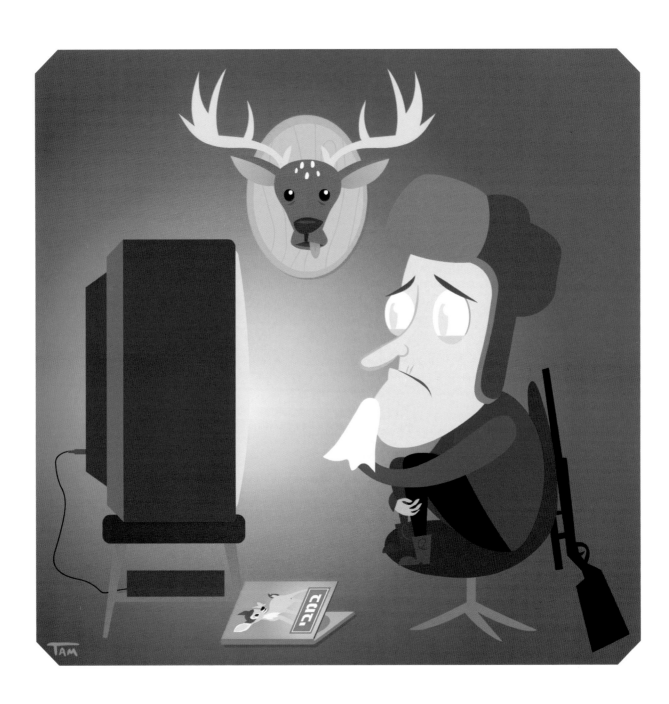

Tamar Moshkovitz

Israel www.go-tam.com tam@go-tam.com

All images © Tamar Moshkovitz

1. I've been a heavy animation addict since I was a kid. I watched every piece of animation on TV: Disney, Warner Bros, MGM, crappy Japanese animation. EVERYTHING the TV had to offer. I also loved going to the movies with my parents and watching old Disney movies, which influenced me a lot with their aesthetics and motion. I've always liked humorous situations, mostly the unexpected ones, and visualizing them was my thing. Learning visual communication and animation as a student helped sharpen my sensitivity to composition, color, and shape. My work is usually animation driven, and I imagine how things will move when they get the chance. I'm also a part of Plushood, a characters project of Shlomi Schillinger (an industrial designer) and myself in which I have the opportunity to translate my illustrations into plush dolls and animation shorts.

2. I work both by hand and with my computer. I enjoy drawing by hand better. I try doing that more often and relaxing that tight ass graphic designer in my brain. Most of my clients get to see my computer side.

3. I've always been inspired by the paintings of Toulouse-Lautrec, Hieronymus Bosch, Dr. Seuss, MAD's Sergio Aragones, Mary Blair's work for Disney. Japanese anime has always made my brain sizzle too. I really love the work of Jim Flora, Glenn Barr, Boris Hoppek, Tim Biskup, Bill Wray, Tomer Hanuka, John K, Miyazaki, Nathan Jurevicius and many more.

4. My work is mostly editorial and animation oriented. I worked mostly on character design for animation series and branding. Most of my stuff is printed, but I also have the chance to shift to 3D and design toys such as Plushood and Toy2R Qees. I also enjoy drawing on all sorts of objects for fun.

5. I'm always working on developing and enriching the Plushood world with my partner Shlomi. Creating more plush dolls, adding more characters, creating new animations and illustrations, pushing the animation series. It never ends! In the future, I wish to create an illustrated novel, make lots of animation shorts, display in more exhibitions, make more toys, and travel around the world with my band of cats.

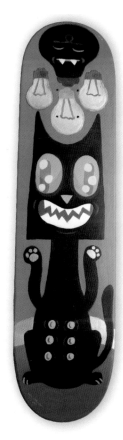

A Very Bad Idea
Acrylic on wooden board.
2007

The New Man
Digital media.
2006

3-2-1...
Digital media.
2005

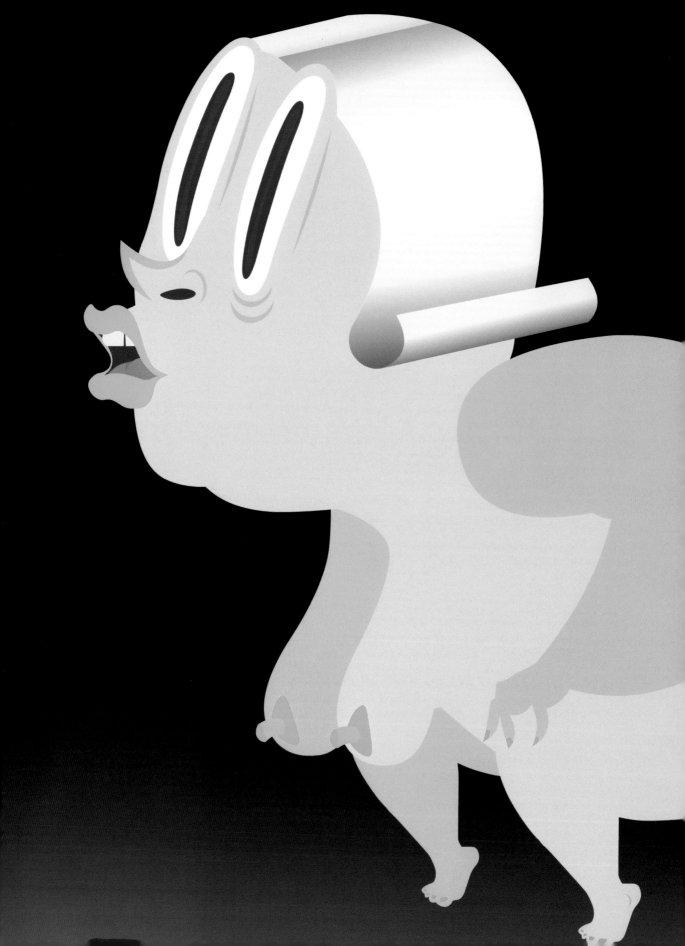

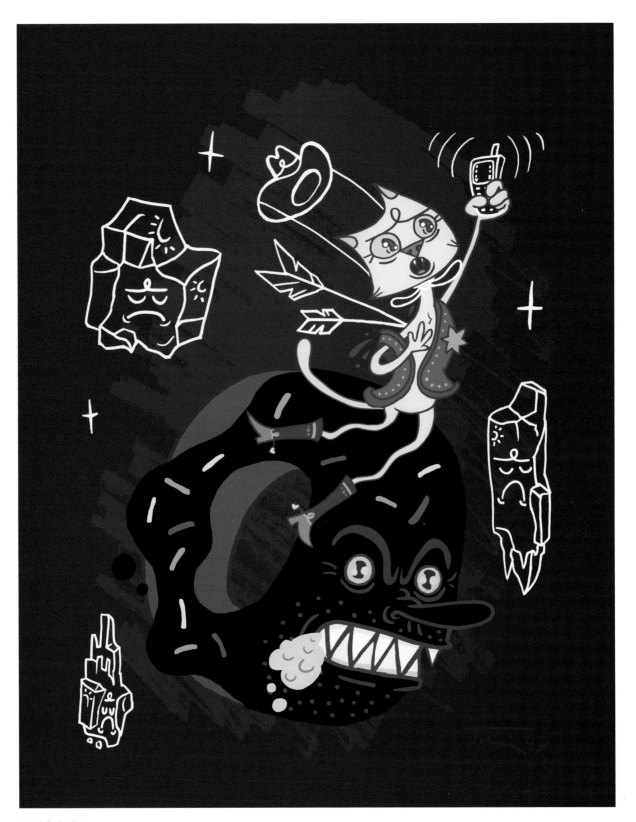

A Baldly Go 01
Mixed media.
2007

A Baldly Go 02
Mixed media.
2007

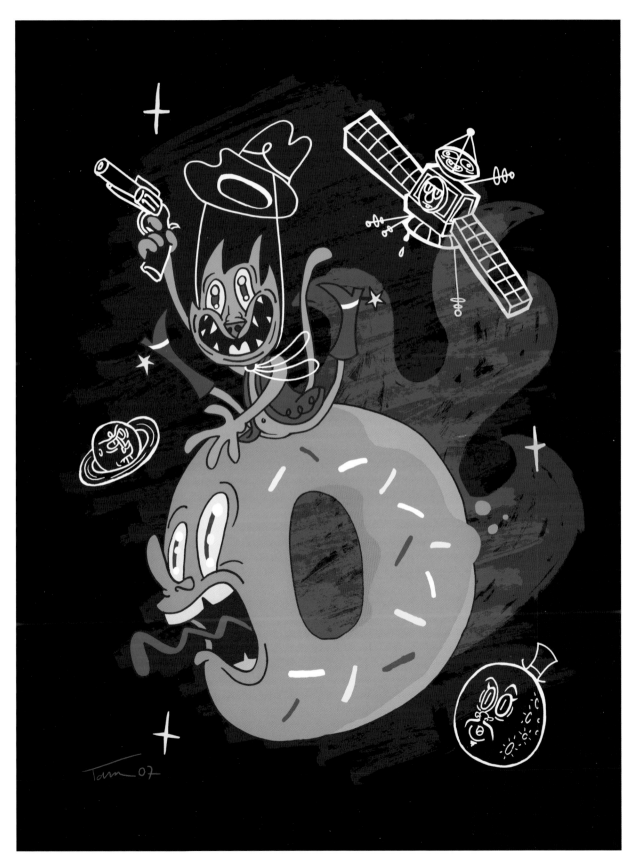

145

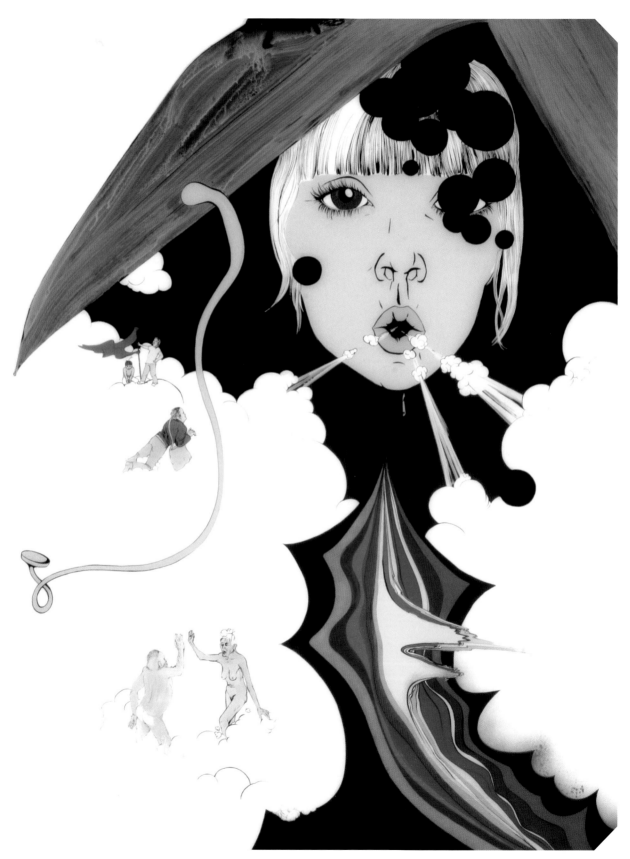

Katharina Gschwendtner

Germany www.gschwendtner.info katharina@gschwendtner.info

All images © Katharina Gschwendtner

1. I never decided to become an illustrator. I just wanted to draw what I did all the time. Then I got jobs after showing my free works. All the pictures you show in the book are works shown in galleries or museums.

2. I always draw with pen and ink.

3. There are a lot of great artists, more or less inspiring my work.

4. The most commercial projects I am asked for are for magazines and advertising. *Spring* is a magazine I edit with a group of artist friends. It shows drawings between comic and art, we always have a topic we talk about. The last book had the title "Garden of Eden." Look at www.spring-art.info.

5. I have to work and the results are always surprising for me.

Finger
Painting behind glass.
2004

Breath
Painting behind glass.
2004

Supper
Painting behind glass.
2005

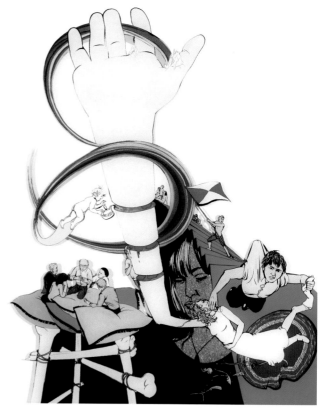

Discussion Group/Angel
Painting behind glass.
2005

Kiss Of The Duck
Painting behind glass.
2005

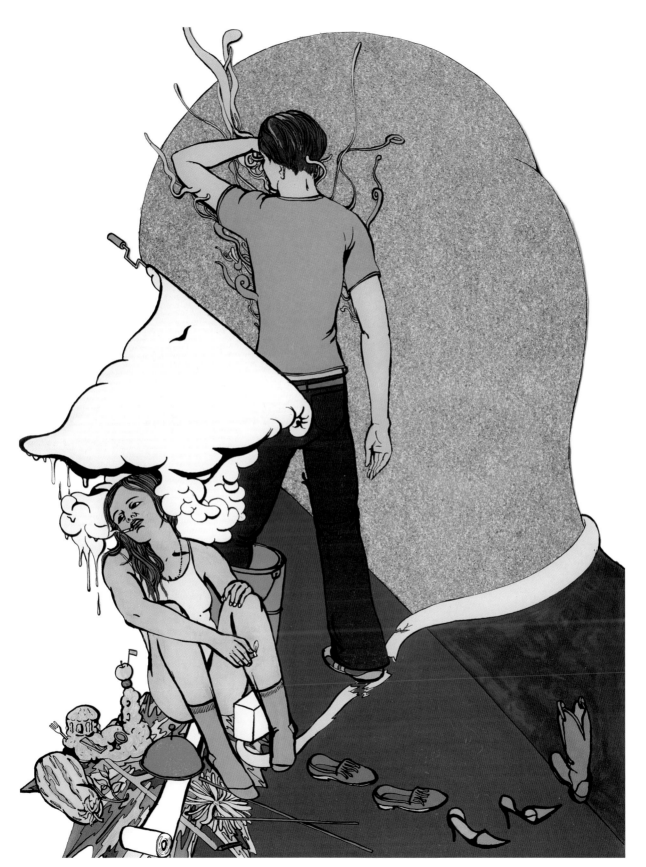

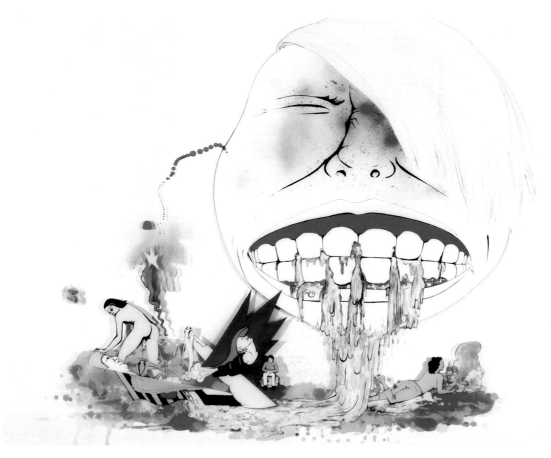

Andy Pollock
Painting behind glass.
2004

Clods
Painting behind glass.
2004

Mushroom Head
Painting behind glass.
2005

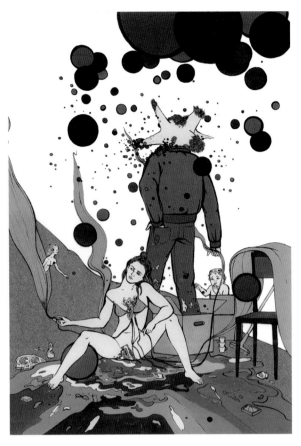

Ghost
Painting behind glass.
2003

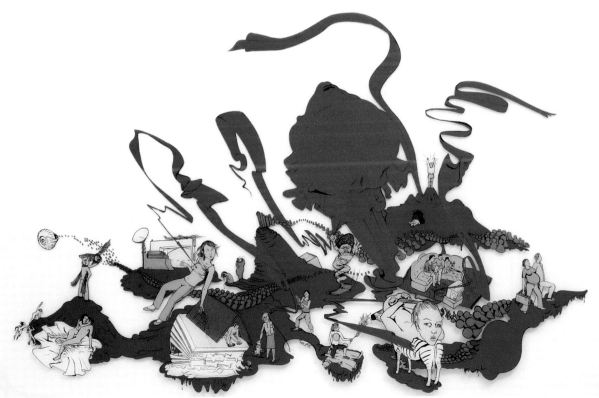

Jason D'Aquino

USA www.jasondaquino.com jasondaquino@hotmail.com

All images © Jason D'Aquino

1. My drawings and illustrations deal primarily with the themes of human corruption and loss of childhood innocence. They are the pages from a children's book gone bad. My work has been described as dark and disturbing, wicked and mischievous. The images often contain very serious and grim content, shrouded in sweetness, like a bitter pill coated in sugar.

2. I work exclusively in graphite, often in extreme miniature, utilizing architectural drafting tools and high-magnification jeweller's glasses. None of the paper I draw on is artificially aged. The surfaces are all antique found objects, and the search for these one-of-a-kind canvases is a distinct part of my artistic process.

3. My favorite artists include George Grosz, Ed Keinholz, Wayne Anderson, Robert Craig, Ralph Steadman, Amanda Wachob, Hans Bellmer, and Henry D'Arger.

4. My work tends toward the darkly humorous—sometimes even horrific. Past clients have included horror, and science fiction publishers, toys and games, and even political printwork.

5. I am currently working on a solo show for the coming year in New York City. I'm developing a screenplay and presenting a compilation of my fine art drawings and miniatures to be published in book form.

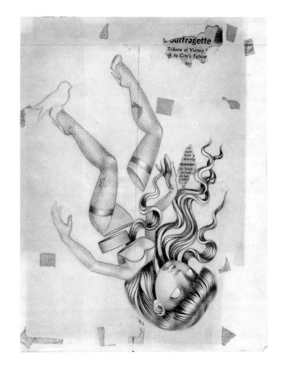

Suffragette
Graphite on found surface.
2007

Candy Shoppe
Graphite drawing.
2006

Peanuts Cover-Ups
Graphite drawings on found
vintage gamecards.
2006

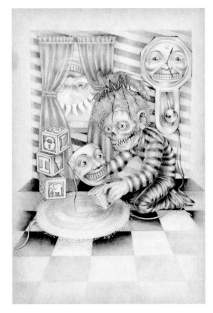

Lie
Graphite drawing.
2006

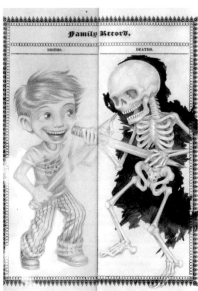

Life
Graphite drawing on
antique Bible pages.
2007

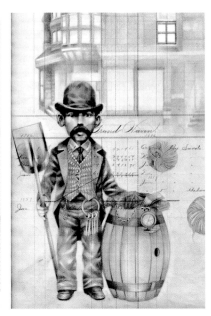

H. H. Holmes
Graphite miniature on antique
ledger paper.
2007

Cowboys and Injuns
Graphite drawing on reverse of antique
movie lobby card.
2005

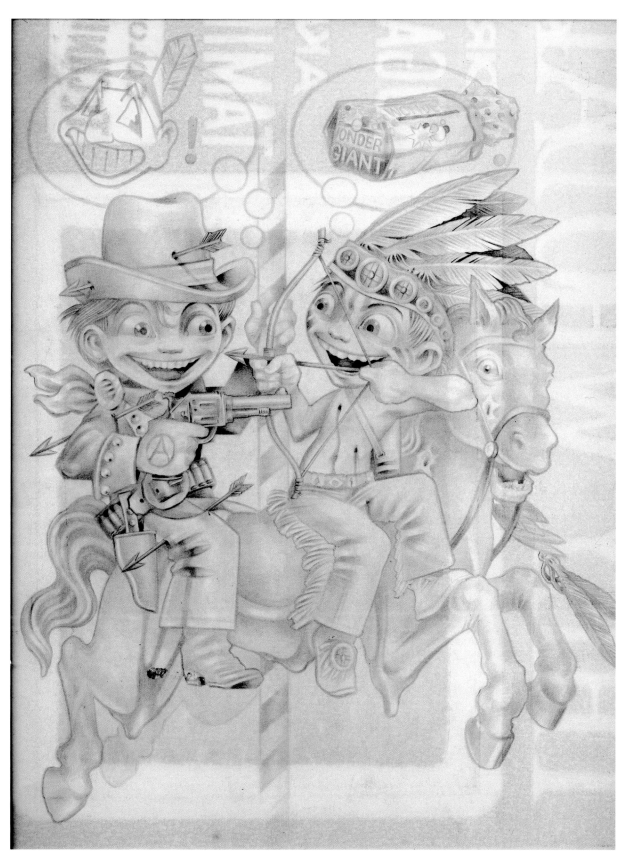

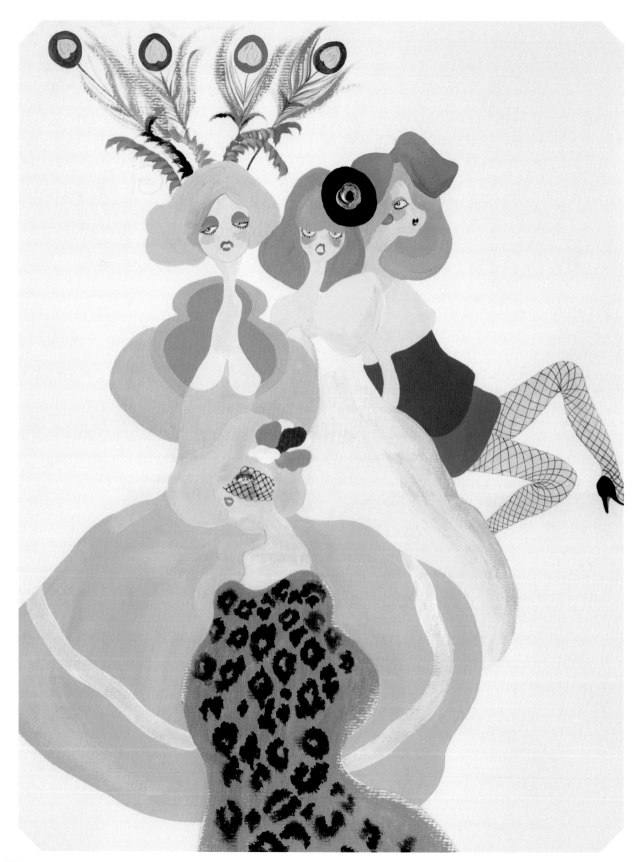

Gi Myao

UK www.gimyao.com gigipoo@gmail.com

All images © Gi Myao

1. When I was just four years old, I started to use anything I could get my hands on to paint on my bedroom wall, including my mum's lipstick and mud! My parents were left with no choice but to take me to drawing classes. Since then, I've spent twelve years in different art schools before becoming a student at Central Saint Martins.

 I have traveled a lot and studied in many different schools in different countries. Everything I have seen and learned grew to be my influences and inspirations.

 I graduated with a BA in fashion design with marketing from CSM in 2006. My final project illustrations won the Nina De York Illustration Award. I soon found people to enjoy my works as much as I enjoy the process creating them, and have since joined Creative Syndicate Agency.

2. I used acrylic and poster paints. I love their flashy and glowing color. My little secret is always use a pencil first.

3. I love old-fashioned illustrators like Honor Appleton and Ronald Searle.

4. Fashion, of course. My work is full of passion for fashion.

5. I'd love to see my work on wallpaper, china, or even on buses.

TwoGirls
Acrylic.
2007

Couture
Acrylic.
2007

Bebe
Acrylic.
2007

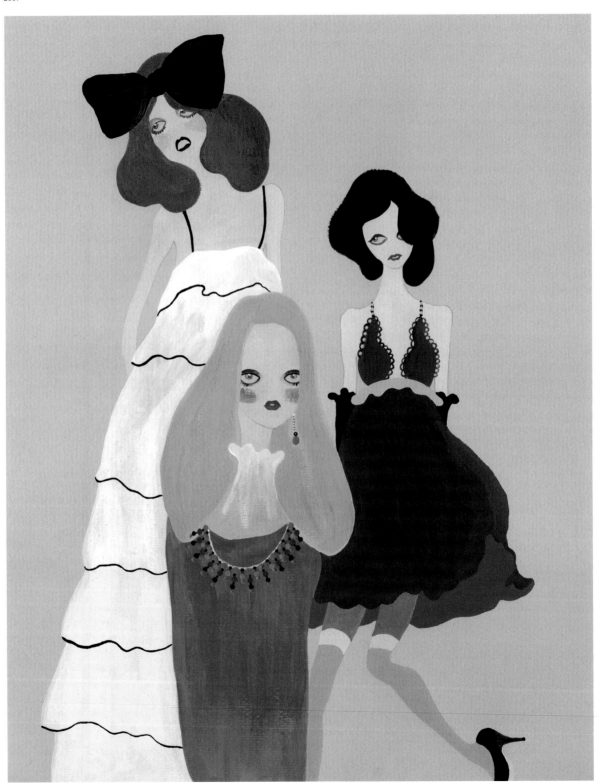

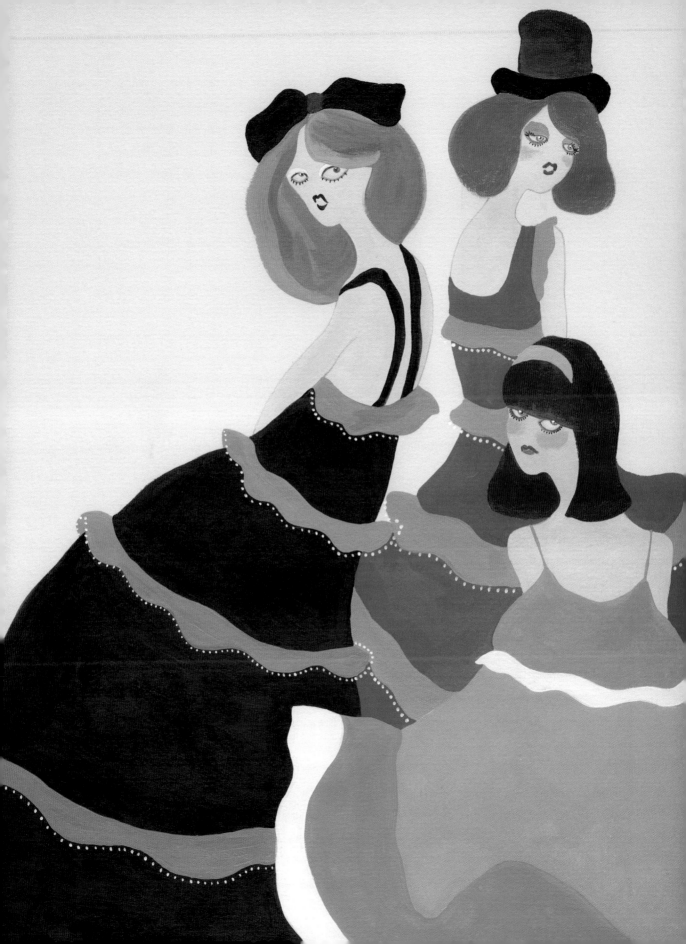

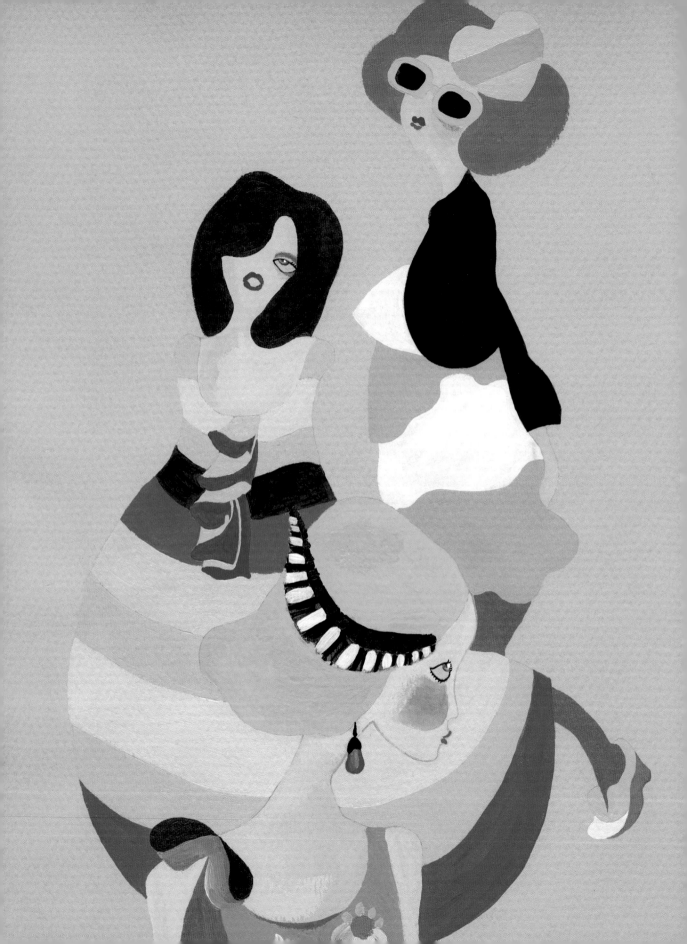

Darling
Acrylic.
2007

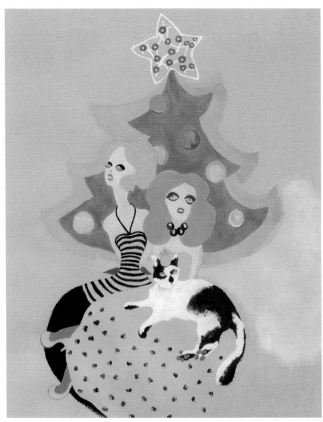

Xmas
Acrylic.
2007

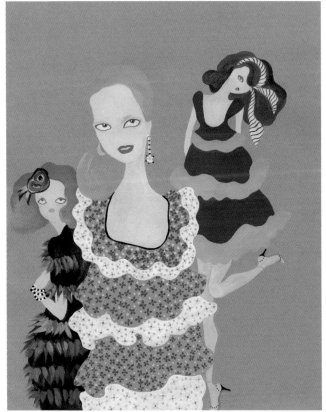

Joy
Acrylic.
2007

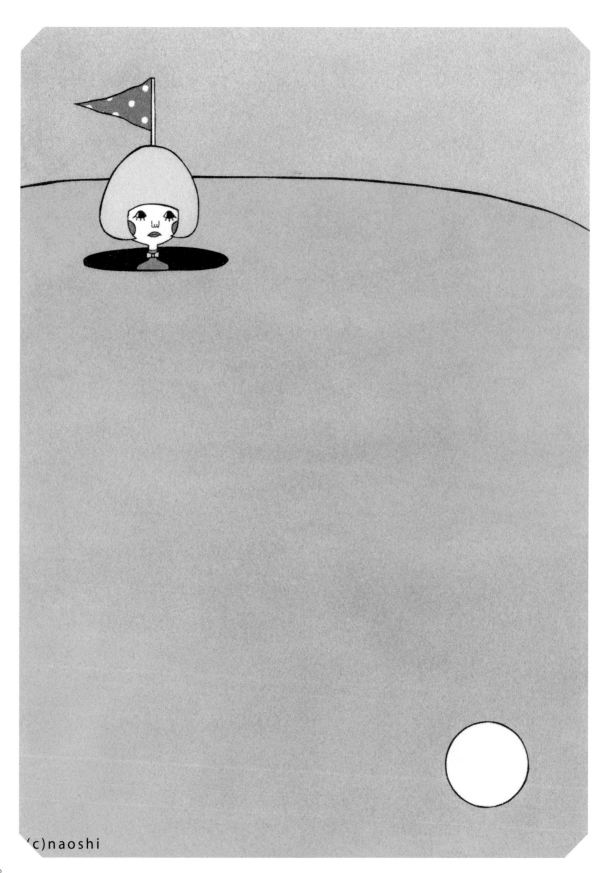

Naoshi

Japan www.naoshii-u-ii.com naoooshi@hotmail.com

All images © Naoshi

1. In 2004, I released postcards at Gips Studio, which started my activities as an illustrator/artist. At first, I mainly exhibited artworks at galleries or cafes in Japan, but recently expanded activity to other regions. Especially this year, I participated in exhibitions overseas such as Shanghai, Italy, USA, and Mexico.

2. Painting by sand is called sunae in Japanese. Sunae is a very sensitive painting method. The appearance can change by only moving one grain of sand, and one cannot modify color easily. However, when completed, the feeling of accomplishment is amazing. Because of that, I keep creating the sunae.

3. Mr. Kin Shiotani (illustrator) gave me an opportunity to start painting. He is not only an illustrator, he also writes plots, lyrics, declamations, live paintings, and so on. I, myself, hope to keep painting artworks that audiences are able to enjoy.

4. When I say "I'm painting SUNAE," a person will often say that "I also used to do this kind of painting when I was child!" So, I would like to create illustrated books that adults and children both are able to enjoy.

5. I'm planning to participate in a group exhibition in the U.S in 2008. Additionally, I have many projects running at the same time.
I want to continue my activity to show such sensitive, dynamic, pop, and surreal sunae not only to Japan but also other many countries!

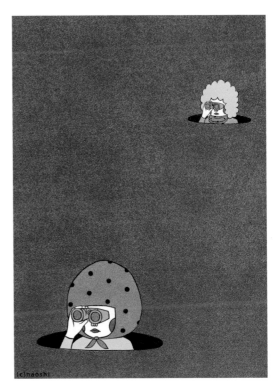

Twins Peeking
Sunae (sand painting).
2007

Break and Enter
Sunae (sand painting).
2007

The bad habit of a guy who lives in Post
Sunae (sand painting).
2007

The holiday of Shampoo girl
Sunae (sand painting).
2007

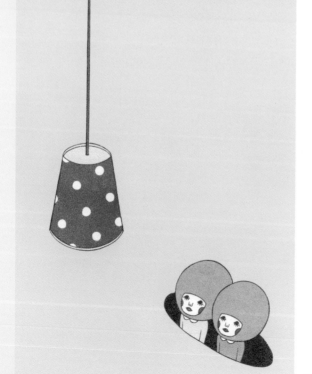

String Telephone from the future
Sunae (sand painting).
2007

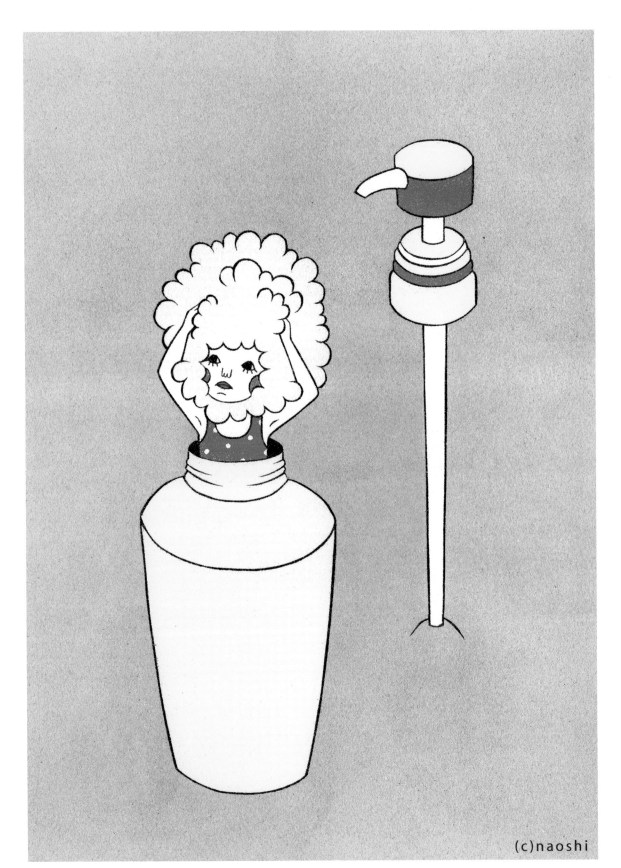

(c)naoshi

House owner's trouble
Sunae (sand painting).
2007

(c)naoshi

The ceiling boy's love
Sunae (sand painting).
2007

HOTDOG COLD WAR

OUR MISSILES

Taepodong
Nodong
Abdali
Ghaznavi
Shaheen

Ababeer
Hongniu
Hongqi
Kaishan
Taurus

Lieying
Penlung
Qianwei
Condor
Ikara
Malkara
Martel
Trigat
Apache
Exocet
Magic
Meteor
Roland
Nord
Armiger
Kormoran
Delilah

Akash
Trishul
Agni
Surya
Sagarika
Nirbhay
Fateh
Shahab
Al-Samoud
Abadil
Al Hussein
Al Abbas
Barak
Jericho
Popeye
Shavit
Ghauri

Babur
Raad
Ingwe
Mokopa
Umkhonto
Hsiung Feng
Sky Bow
Sky Bear
Sky Sword
Bloodhound
Blowpipe
Blue Steel

Green Cheese
Red Dean
Sea Cat
Sea Dart
Sea Eagle
Sea Slug
Sea Slug
Sea Wolf
Storm Shadow
Swingfire
Thunderbird
Tiger Cat

Nuke

OUR CONDIMENTS

Tomato Chutney
Salsa cruda
Salsa Verde
Pesto
Plum sauce
Sweet & Sour
Teriyaki
Bordelaise
Sauce Africaine
Panco

Sambal
Green Mole
Mornay
Hollandaise
Sauce Americaine
Sauce Allemande
Garlic Chutney

Mustard
Curry
Pickle Relish
Swiss Cheese
Jalapeño
Celery
Spaghetti
Tartar sauce
Mang Chutney
Worcester hire
Cocktail Sauce

Ketchup
Sauerkraut
Mayonnaise
Camembert
Coney Sauce
Onion
Chow-chow
Wasabi
Ranch sauce
Horseradish
Belacan

Chili
Cole slaw
Pickle Spear
Ball Cheese
Dill Pickle
Picalilli
Ajvar
BBQ sauce
Trassi
Giardiniera
Remoulade

Riiko Sakkinen

Spain www.riikosakkinen.com riiko@riikosakkinen.com

1. If illustration is the act of making things clear and distinct, I think that's what I do. I do realistic drawings about the world–no Utopias, dreams, or deliria. But if illustration is decorating texts and advertisements, I have nothing to do with it.
 I've done 1789 drawings so far and do around 100 more every year. My favorite themes are special offers, prostitution, ice cream, riots, and chemical warfare. When I was a kid, I wanted to be a revolutionary guerrilla but I ended up being artist–it's much safer and more comfortable.

2. To make a good drawing, I need:
 Low-quality paper, German top-quality watercolors, Japanese felt-tip pens, Chinese green tea, Belgian beer, podcasts of Finnish radio programs, Pocky, the late CDs of M.I.A, Prin-la-lá, Facto Delafe y Las Flores Azules, Vanexxa and Manu Chao, ballpoint pens with hotel logos (in many different tones of blue), newspapers, confectionary wrappings, breakfast cereal boxes, and Wikipedia.

3. Maybe they are not illustrators but they do great drawings: Judas Arrieta, Fernando Bryce, Suzanne Dery, Eemil Karila, Misaki Kawai, Kalle Lampela, Yoshitomo Nara, Cecilia Stenbom, and Katja Tukiainen.

4. I'd love to illustrate advertisements for Exxon, Shell, Lukoil, Repsol and Petrochina–some of the biggest oil companies–and draw Molotov cocktails for them.

5. I want to be rich and famous.

Everyday bread
Mixed media collage on paper.
2005

Hot Dog Cold War
Mixed media collage on paper.
2007

Eat & Vomit Cup Noodle Wars
Mixed media collage on paper.
2007

Boxer Trouble
Mixed media collage on paper.
2007

Eat Me Ramen Pig
Mixed media on paper.
2007

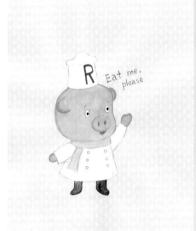

Teens from Tokyo
Mixed media collage on paper.
2007

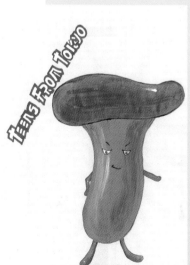

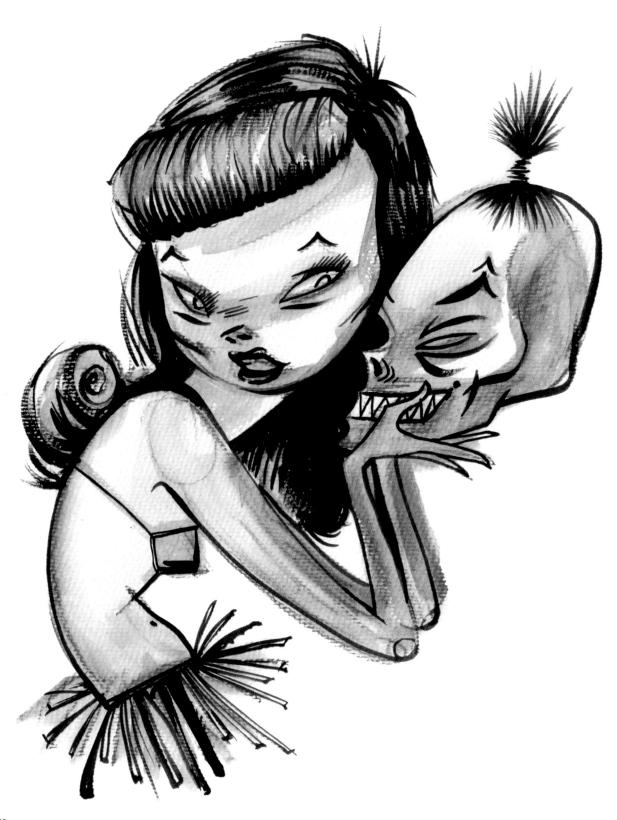

Illurama

Holand www.illurama.nl leendert@illurama.nl

All images © Illurama

1. I mainly work for magazines and newspapers, but also I design prints for products like t-shirts, tablecloths, and pillows. In technique I show a combination of hand-drawn and computer-made work, my style often a combination of humor and a more serious approach.
I graduated in 1992 from the academy of Arts and Industry in Enschede, The Netherlands and moved to Amsterdam in 1993 to start my one-man studio.

2. I work in different techniques, mostly combinations of hand- and digital work, and like to experiment with all techniques I can lay my hands on. Colored pencils, acrylic paint, stencils, markers, ballpoint, Photoshop and Illustrator.

3. Tim Biskup, Fiep Westendorp, Kiraz, Yoshitomo Nara.

4. I work for all kinds of magazines and newspapers. Because I use different styles and techniques, I can find a visual translation for almost every subject. I can fulfill many different kinds of comissions without losing my own style.
In the past my work has mostly been used for editorial purposes, but has also been used in advertising, as prints for bags and shirts, logos and graphic design.

5. I hope I will draw on forever, Illurama island is my favorite place to be.

Tiny Tears
Digital.
2005

Cannibal Island
Gouache on paper.
2005

Lucifer Nest
Digital.
2007

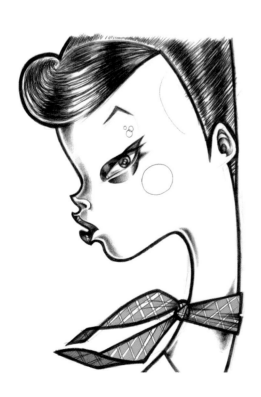
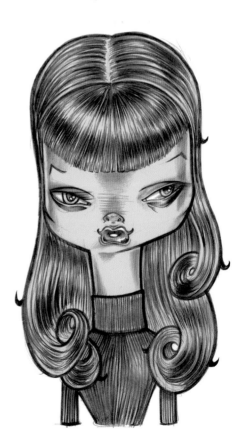

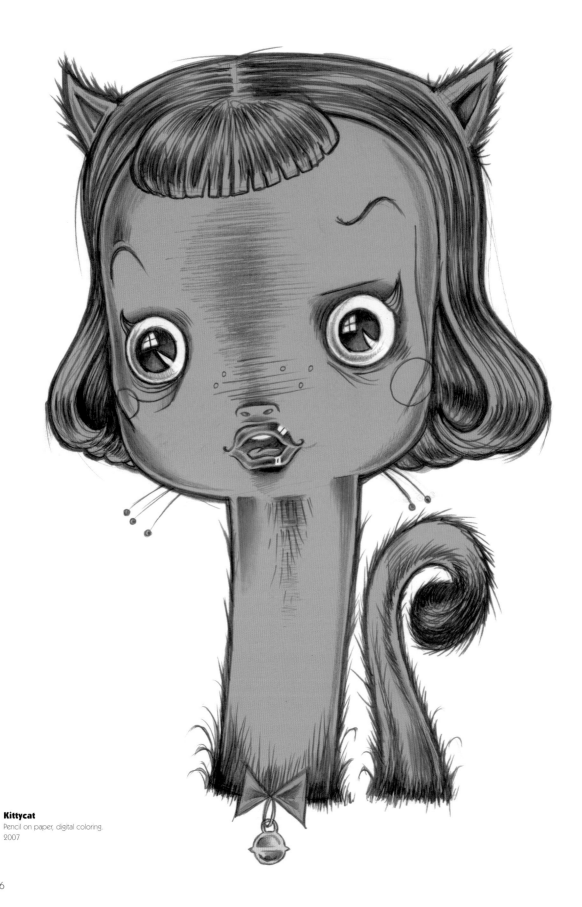

Kittycat
Pencil on paper, digital coloring.
2007

Bubblegum
Ink on paper, digital.
2004

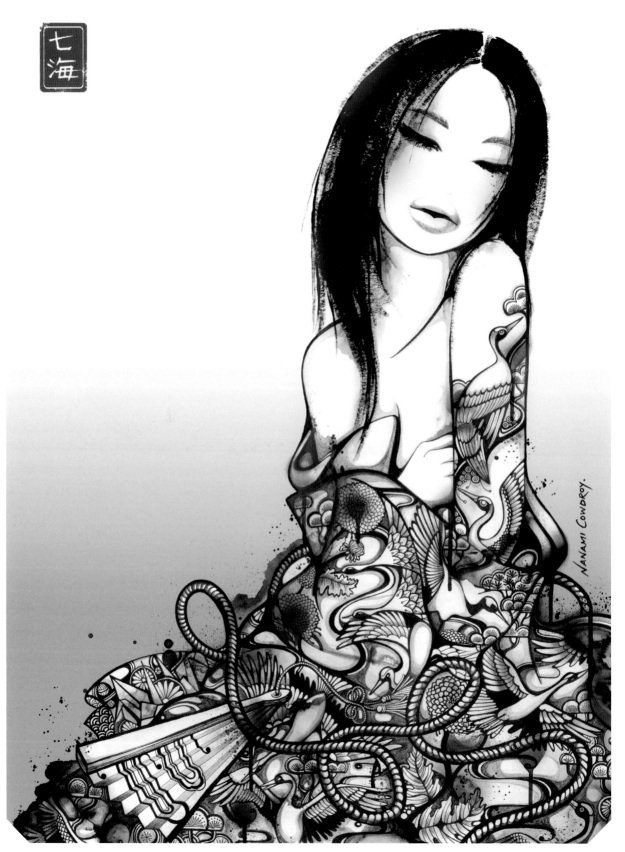

Nanami

Australia www.nthread.net nanami@nthread.net

All images © Nanami

1. I define myself primarily as an artist, as my work is a combination of elements. Art, illustration, and design have always been a huge part of my life, it's my love and passion. I come from an artistic family, I received a bachelor of design in visual communication at the University of Technology, Sydney and have worked as a graphic designer over the years. Today I am a solo artist, doing my own thing.

2. I love creating inky interpretations of things, scenes, and creatures. I love black ink, using my hand-drawn pencil and ink illustration, watercolor, and spray painting, combining it with mixed media, for example, some graphic elements and, at times, collage/photography.

3. I have so many! Jordi Labanda, Joe Sorren, Rocco Fazzari, Brett Whiteley, M.C. Escher, Hayao Miyazaki, Buff Diss, Jamie Hewlett, Arthur Horner.

4. To be honest, my artwork isn't directed for any particular sector or industry, it's a personal art style which I guess can lend itself to different creative fields depending on what they are, and what they represent. I create my images mainly for myself.

5. I'm very excited, looking forward to having more exhibitions in Sydney and overseas. I can't wait to travel some more and see the world, armed with my pens and pencils. I'd love to continue creating more fashion artworks as well as art for objects. The most important dream for me is that I really hope people enjoy my work. It encourages me to continue doing what I love doing the most, art :)

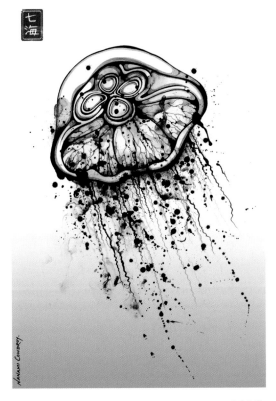

Ink Jelly
Hand-drawn and painted with mixed media.
2007

Geisha Yume
Hand-drawn and painted with mixed media.
2006

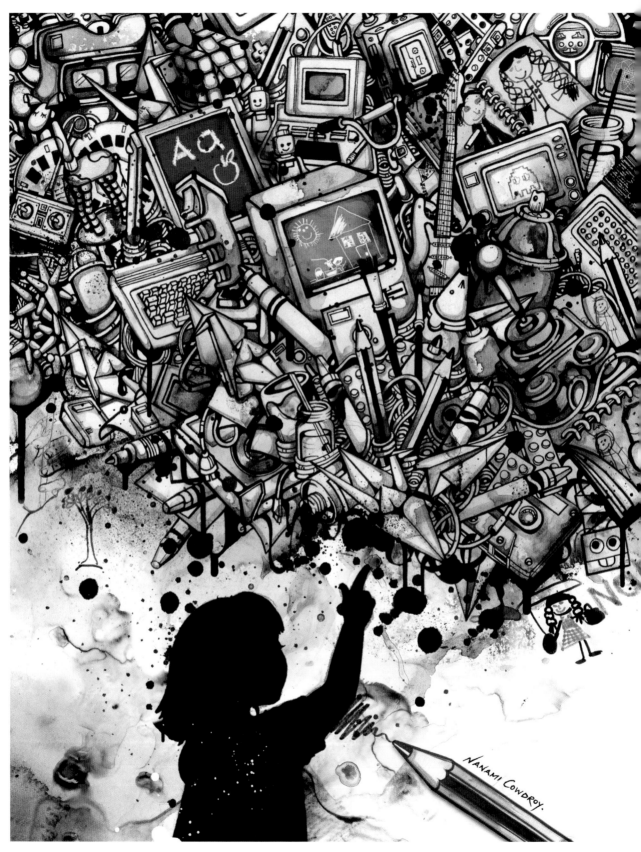

NANAMI COWDROY.

Ink Fish
Hand-drawn and painted with mixed media.
2007

Imagination Cultivation v2
Hand-drawn and painted with mixed media.
2007

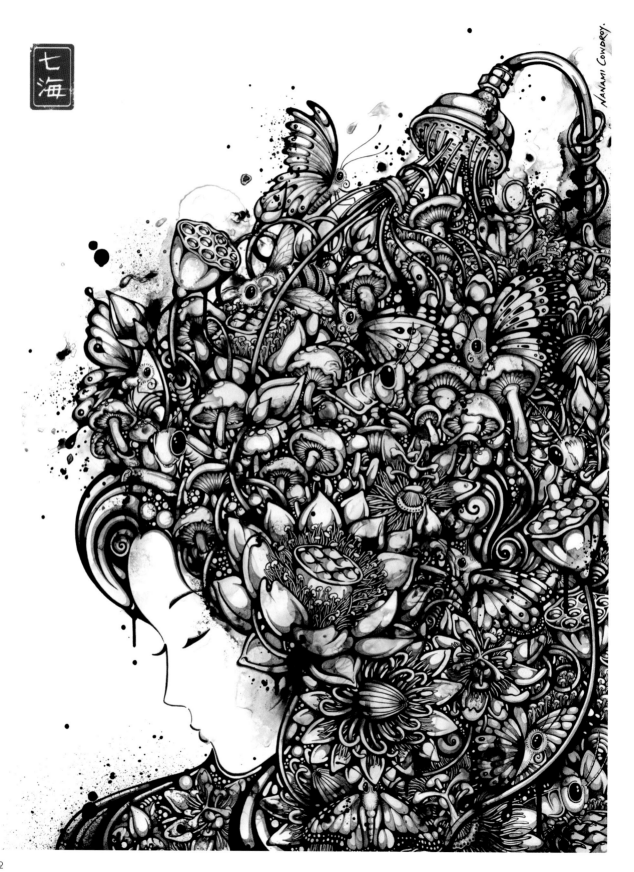

NANAMI COWDROY.

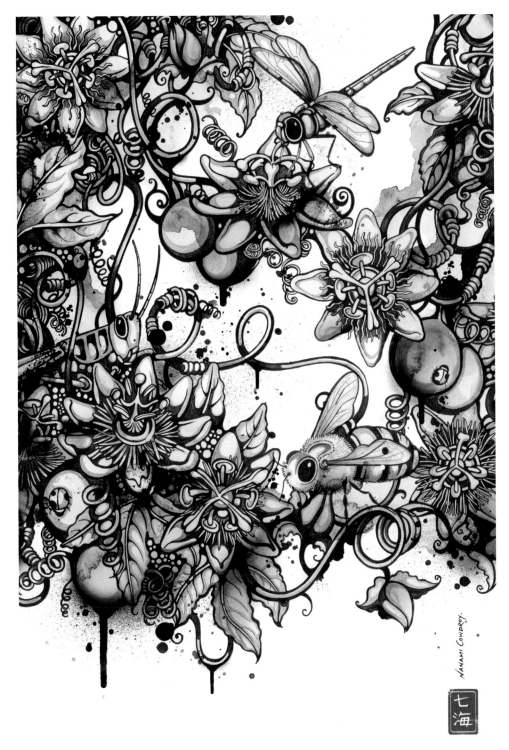

Inksects
Hand-drawn and painted with mixed media.
2006

Flower Shower
Hand-drawn and painted with mixed media.
2007

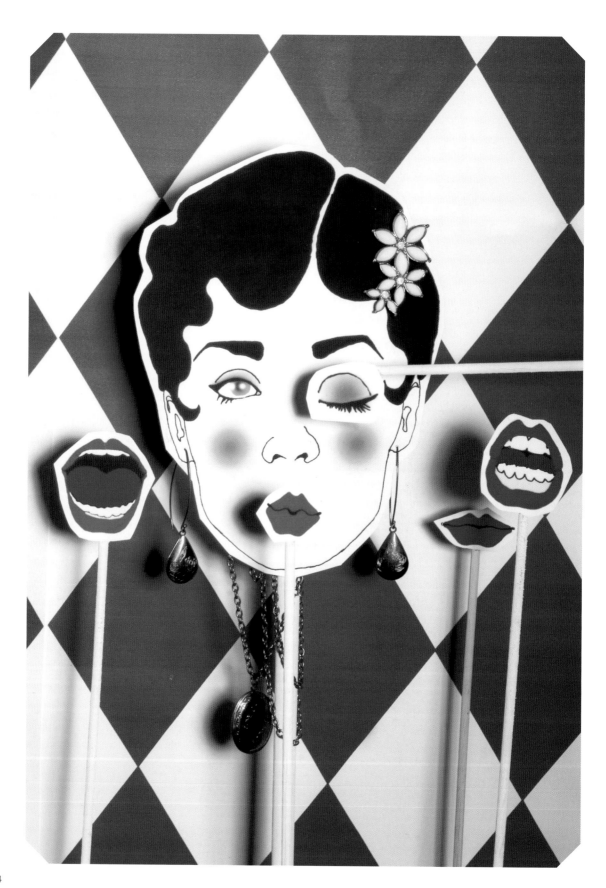

Ingela och Vi

Sweden www.ingelaochvi.com pt@ingelaochvi.com

All images © Ingela ochi Vi

1 & 2. Design concept: Early Walt Disney, paper theater, past time, Chinese shadowplay/theater, and origami. Most of our ideas we get from movies, music and just daily life. To begin our process we plan for an example, how the room shall look and how the characters shall act. The work continues with the characters which are illustrated to convey the right expression. Then they're cut out in paper and dressed with textilies to increase the 3D. The characters are then placed in the scenario as actors and to keep them in place we use fishing line, which has become a sort of trademark. To create the right mood lights are set up and then photographed to become the finished illustration. Ingela och Vi started in 2004, after Elisabeth finished five years of studying visual communications at Denmark's Design School in Copenhagen. Peter was an assisant photographer when they met and both wanted to create integrated illustrations in photos. That's when the idea of illustration-photo started. Early in her career Elisasbeth worked with combining 3D with 2D objects but now she can take it to another level with the collaboration of photographer Peter Turkalj.

3. Working with the director Todd Solondz, maybe an animation of one of his scripts.

4. Our work is suitable for magazines, fashion, and advertising. We can't see any boundaries for our work.

5. Continuing our crusade all over the world!

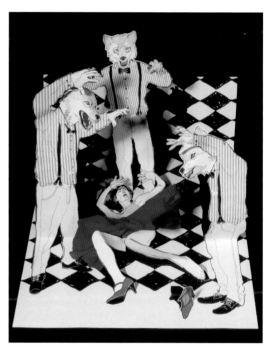

Little red riding hood
Using pop-up.
2007

Paper doll and jewelry
Using set design.
2007

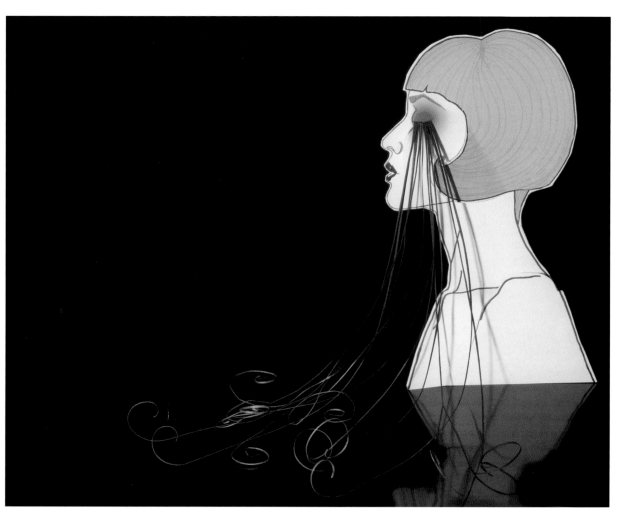

Volume mascara
Illustration photo.
2007

This is heavy Stuff
Illustration photo.
2007

Swing
Illustration photo.
2007

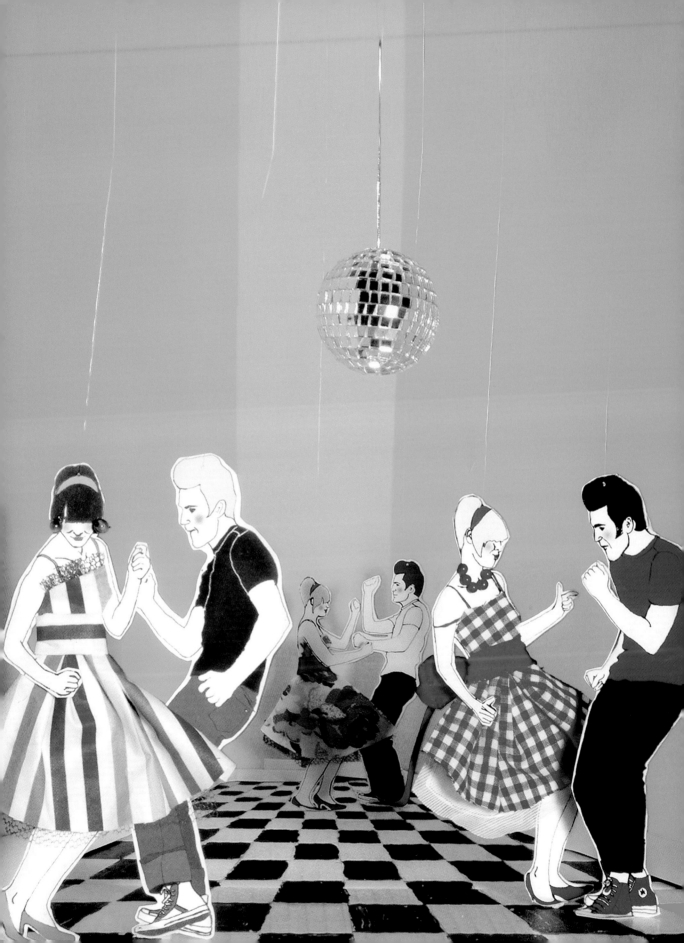

Almudena Hunduro

France www.almudenahunduro.com aho@almudenahunduro.com

All images © Almudena Hunduro

1. I began illustrating purely by chance while a student of the beaux-arts.
 At first, my inspiration came from publishing houses, old penthouses, the flea market, rarities in the foreign press.
 Gradually I came to be partial to drawing and came across two houses willing to represent me. I changed my source of inspiration and have worked for some time on images of my own or by commission.

2. Mixed techniques. Generally I draw something by hand taken from a photographic source, and later digitalize the illustration for the appropriate finishing touches or color.

3. My inspiration comes directly from the fashion world.
 A great aesthetic influence is the photographic works of Steven Meisel, especially his projects working with Italian *Vogue*. His exaggerated style has had a very direct influence on me.
 From my closer panorama, my inspiration has come from the imagination and creativity of fashion designer/illustrator Nu(e) and designer Javier Albiñana with his Citric brand.

4. Essentially fashion magazines. Until now this is for whom I have worked and for whom I create in a very specific way.

5. Principally in fashion. As an illustrator, I am involved in projects with a firm in Paris. Likewise I will also be launching my own t-shirt collection next summer with my illustrations online.

Citric I (Javier Albiñana)
Mixed technique.
2007

Peut-être I
Mixed technique.
2007

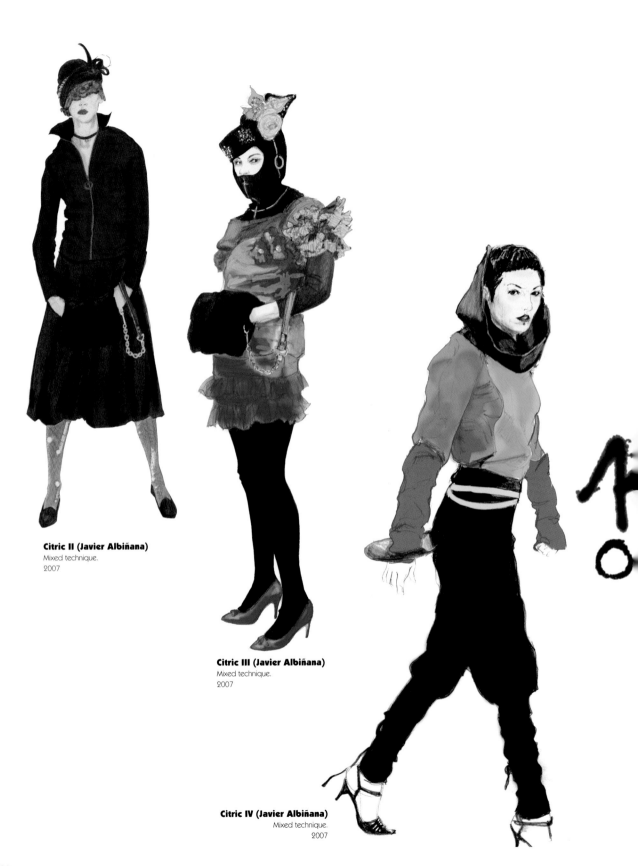

Citric II (Javier Albiñana)
Mixed technique.
2007

Citric III (Javier Albiñana)
Mixed technique.
2007

Citric IV (Javier Albiñana)
Mixed technique.
2007

Citric V (Javier Albiñana)
Mixed technique.
2007

Peut-être II
Mixed technique.
2007

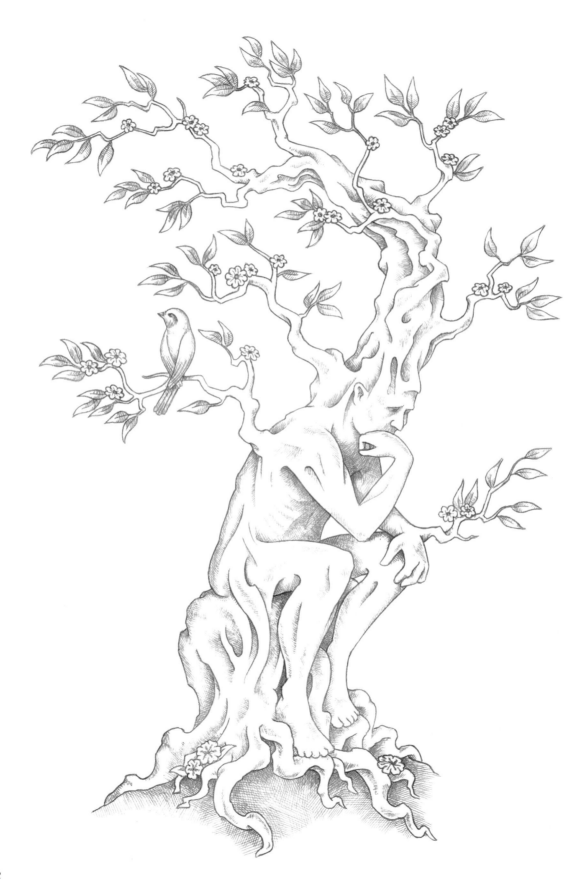

Juan Manuel Morales

Spain www.myspace.com/juan4fz juan4zr@hotmail.com

1. My first drawings go back to before I learned to read, when I painted pictures of horses and trees on the leatherette chairs at home. When I was older I went to art school to perfect my skills and learn about new materials.

2. The ballpoint (only blue) on paper. The beauty of the ballpoint lies in its total simplicity. It is fascinating to see how a work of art can be created through the very same everyday ballpoint used by housewives to check shopping lists, or traffic wardens to fill out parking tickets.

3. Leonardo da Vinci, Alberto Durero, Gustavo Doré, Maurits Escher. It's amazing to see how they worked centuries ago, but how we still continue to be impressed by their masterpieces today through internet screens!

4. Every time I do a drawing, I have the idea of creating a true visual impact which is an artistic work in its own right. So, I don't actually see my work as illustrations merely to support published texts. Rather, I see them enclosed within frames and decorating walls: behind the bar, in the dentist's surgery, a lawyer's office, or a king's palace.

5. I hadn't thought about it. For me the simple fact of finishing a drawing is already nothing short of a miracle, like carving light out of a sheet of paper. So, in the future, even if nobody ever buys a drawing of mine or remembers me from exhibitions, I intend to continue drawing until the end of my days.

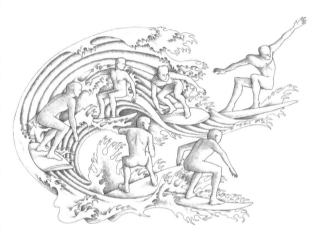

Looking for the perfect wave
Pen on paper.
2007

The thinking tree
Pen on paper.
2007

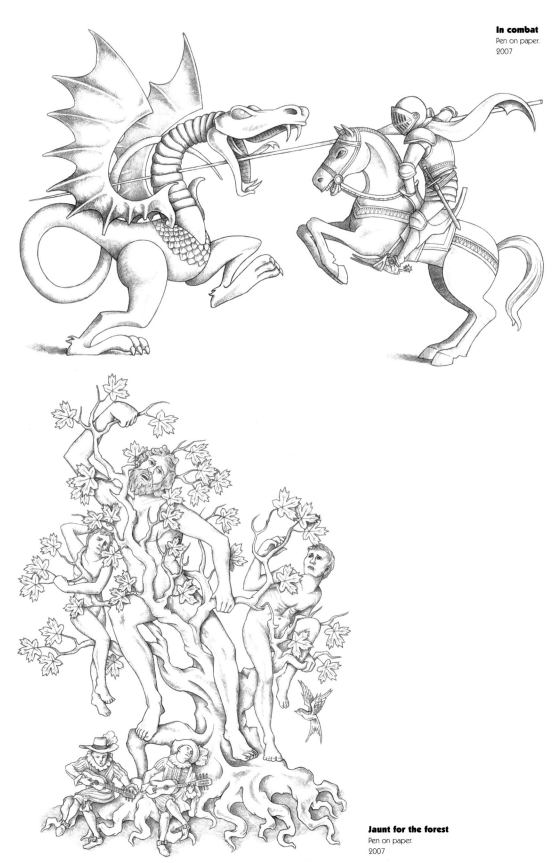

In combat
Pen on paper.
2007

Jaunt for the forest
Pen on paper.
2007

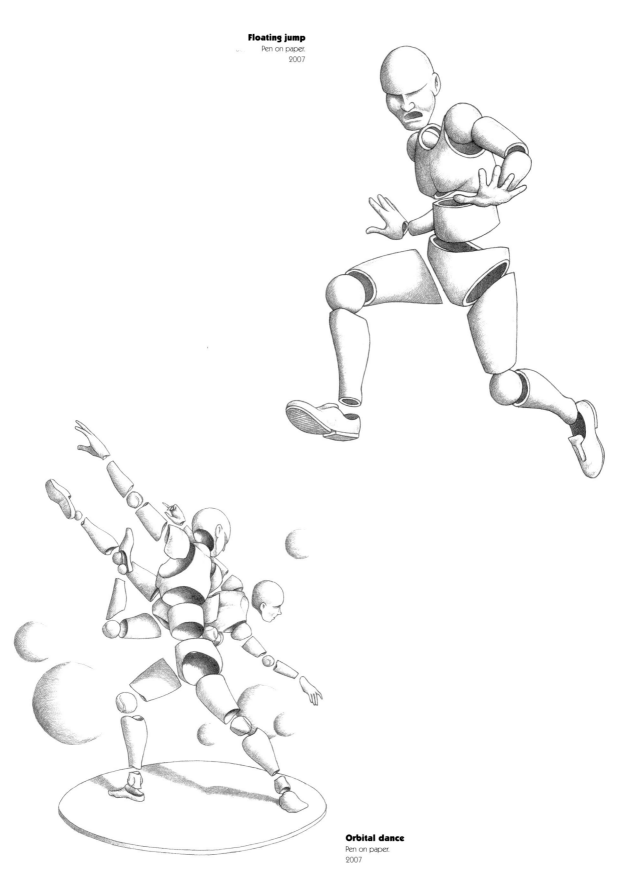

Floating jump
Pen on paper.
2007

Orbital dance
Pen on paper.
2007

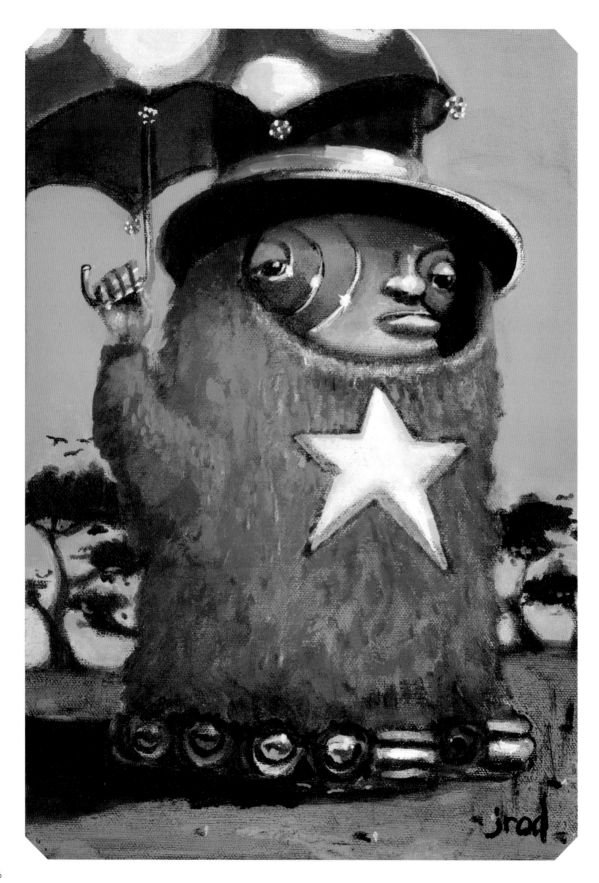

JRODaRT

USA www.jrodart.com info@jrodart.com

1. I define myself as a fine artist. The word *illustration* seems to have become synonymous with commercial work. My work is inundated with tiny messages and a reassuring sense of spirituality. Self-taught for the last eighteen years, I seek the ability to use my imagination and maintain an aspect of professionalism to portray someone else's idea. I am inspired by music, culture, travel, and the characters I meet along the way.

2. Recently, I have been experimenting with a new process using scouring pads, sandpaper, and alcohol. I search for a randomness that cannot be achieved any other way and that captures something that cannot be duplicated. I seek to reassure myself with the symbolism of my beliefs and spirituality in my work.

3. Early in my career, I met Joe Sorren. He turned me on to artists Brad Holland, Marshall Arisman, and Francis Bacon. I grew to admire the loose, but vivid, quality of all their work. Before that it was a fondness for work by Robert Williams, Derek Hess, and Gary Panter, who inspired me to believe in a non-traditional sense of what art was. Roberto Matta was a later discovery, while visiting Madrid, but my earliest memories of striking images are those of Maurice Sendak's book *Where the Wild Things Are*.

4. I try not to pigeonhole my work, but do believe my images tell a story that make them suitable for editorial work.

5. My work is my passion and has become a definition of my time passing. I hope to continue this journey with only an expectation of continued joy and evolution. Art is life.

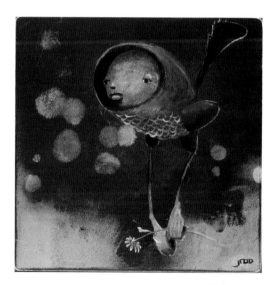

Clairvoyance
Acrylic on board.
2007

Patriot Funk
Acrylic on canvas.
2006

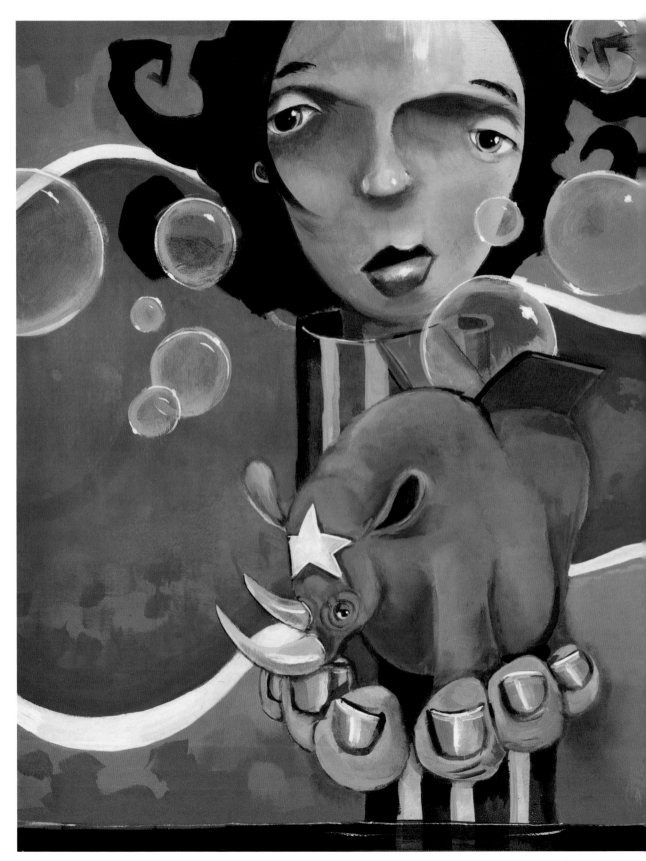

Offering Alternatives
Acrylic on board.
2007

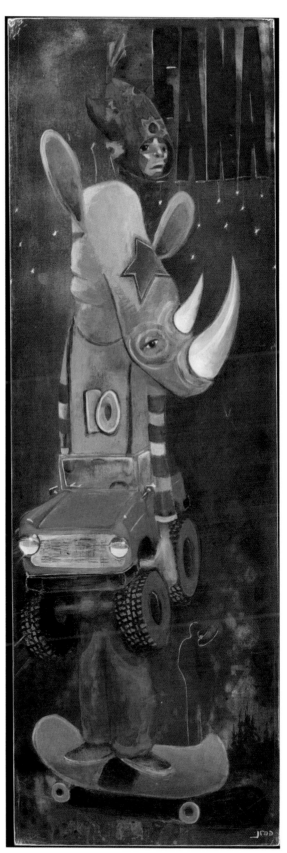

**The Undeniable Truth
of Your Reality**
Acrylic on board.
2007

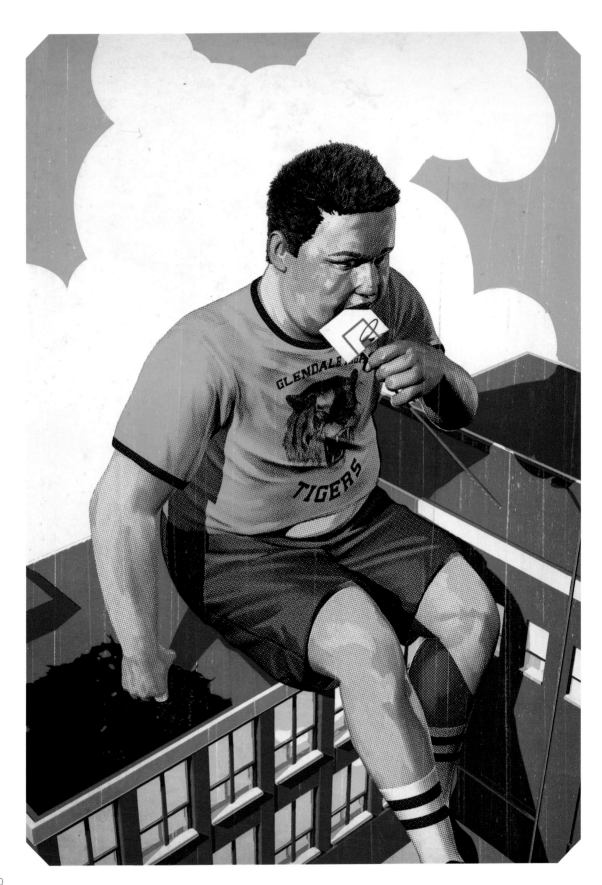

Tavis Coburn

Canada www.taviscoburn.com t_creed@hotmail.com

All images © Tavis Coburn

1. I work out of Toronto, Canada but I studied at the Art Center College of Design in California. My first break came when an art director for A&M Records hired me to illustrate the cover of a promotional CD. That lead to more jobs with other L.A.-based record labels, and the phone really hasn't stopped ringing since, fortunately. I draw inspiration from the graphic design and illustration of the 1940s, 1950s, and 1960s. There's something amazing about the art of that era, when draftsmanship was revered and designers couldn't fall back on the undo key. Whenever I'm stuck, I look to the work of that era to find a brilliant, time-tested solution.

2. I used to render my subject in gouache, combining my painting with a few digital elements, and then screen print my finished piece. With no flexible digital file, it was never good to hear art directors (who often thought that my work was collage) request changes. Over the years, I've developed a mostly digital process that mimics my old stuff. Not everything is done in the computer, which would leave the artwork feeling cold and too clean, but doing things digitally lets me get a few more hours of sleep every night. The real secret is in searching for the time-saving solutions that don't compromise the qualities of your work.

3. I've always admired the work of Jason Holley. His work is consistently great and he's always willing to make bold decisions. I was lucky to be able to study under him at Art Center.

4. I try not to limit myself in that regard. An advertising agency that wants a smart visual solution to sell a car is not much different from a magazine that wants to attract a reader. I like the idea of exploring projects from all over the spectrum to keep things fresh and fun for myself.

5. I'm actively seeking motion graphics projects. I like the idea of tackling projects that, on the surface, have nothing to do with illustration, but that are all about finding design solutions.

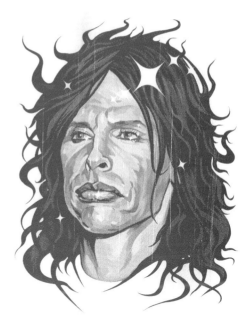

Steven
Digital.
2006

Gym Class
Digital.
2007

Buck
Digital.
2005

The Greening
Digital.
2007

Top 5
Digital.
2005

Courtney James

USA www.punkychicken.com cjames@punkychicken.com

All images © Courtney James

1. I currently attend College for Creative Studies. I have studied classes ranging anywhere from graphic design to photography and painting. Nevertheless, my true love is the creation of digital art and design. This medium has given me the opportunity to accurately express my own personality and depict the elements that make this world beautiful.

2. My illustrations are typically figurative, incorporating organic forms found throughout nature. I am constantly being inspired by all that surrounds me, the love and support in my life is what drives me to continually reinvent myself. My designs are usually made in Illustrator and Photoshop with the use of many layers and intricate lines. I am always trying to create designs that evoke emotion and thought.

3. It is hard to look anywhere without being inspired. We live in a world where art has become such a large part of our everyday lives. I take much of my inspiration from artists in the period such as Aubrey Beardsley, Alphonse Mucha, and Toulouse-Lautrec. Another artist that I have great respect for is Patrick Nagel, for amazing ability to depict women in such a beautiful way.

4. I feel that my art fits almost any form, whether it is magazine spreads, print ads, fashion material or album art.

You are Free
Digital art created in Illustrator with
the pen tool.
2007

In the Underground
Digital art created in Illustrator with
the pen tool.
2007

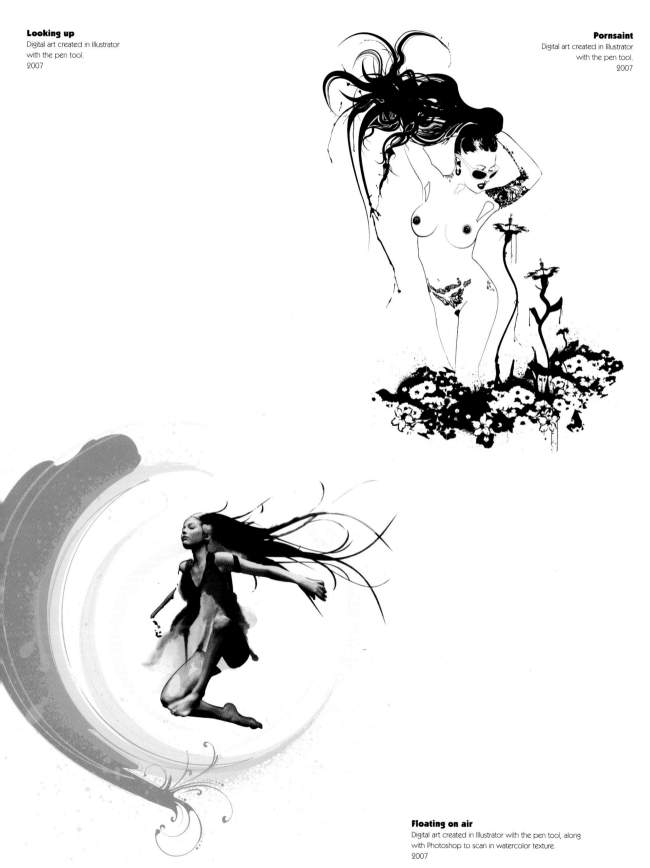

Looking up
Digital art created in Illustrator
with the pen tool.
2007

Pornsaint
Digital art created in Illustrator
with the pen tool.
2007

Floating on air
Digital art created in Illustrator with the pen tool, along
with Photoshop to scan in watercolor texture.
2007

Skizzomat

Germany www.skizzomat.de marie@skizzomat.de

All images © Skizzomat

1. I do design for motion graphics, as well as art direction for exhibition design (e.g., MINI). My projects always focus on creating intense picture-based worlds, so the step into illustration was quite obvious. My career in professional illustration started about three years ago, when www.skizzomat.de was launched. Published in: *Vorn* magazine, *Zeit* magazine, *NEON* magazine, *Wad* magazine, *INDIE* magazine, *PIG* magazine.

2. Skizzomat illustration is digital collage and graphics, always aiming for the strengh of (new) shapes in a composition, often working in black-and-white, on high contrasts, in a quite two-dimensional way. Details are still hand-made: analog cut-outs, paint brushes, scribbles, stickers, photocopied images over and over.
 Found footage is essential: paper, textures of any material, pieces of (foreign) typography, photographs of people Marie always tries to find a story behind things.

3. Daniel Egnéus: the power of lines, the layering, his architectural compositions, the variety of black and white. Glufolio: powerful colors, graphically reduced expression. Spanish artist Ester Partegàs.

4. Magazines, fashion, advertising, motion graphics, storyboarding.

5. An exhibition to try out how skizzomat artwork feels and interacts in a 3D space. Going back to moving media projects.

To dos
Digital collage.
2007

Abendmahl
Digital collage.
2007

Boxer
Digital collage.
2006

Heute: Wie Immer
Digital collage.
2007

Atari
Digital collage.
2007

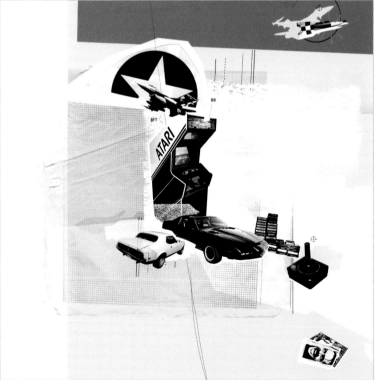

Zwischen
Digital collage.
2007

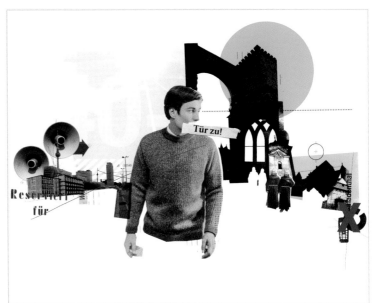

Female
Digital collage.
2007

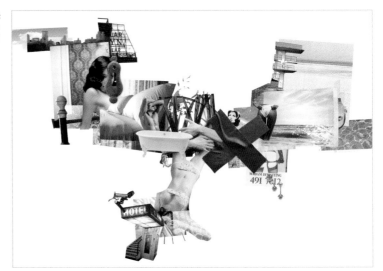

White Woman
Digital collage.
2007

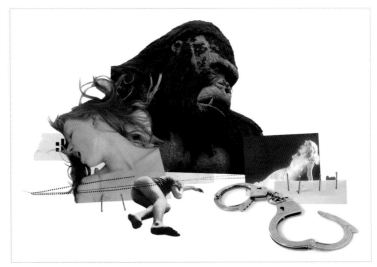

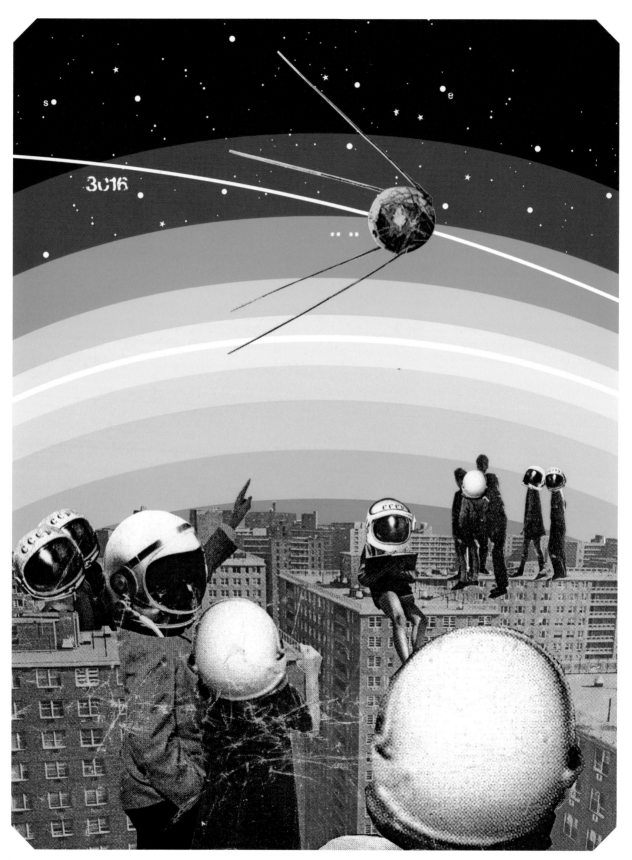

Mario Wagner

Germany www.mario-wagner.com mario@reflektorium.de

All images © Mario Wagner

1. I studied at the Aachen University and work as an artist and illustrator in Cologne, Germany. My unique illustrations and artwork are commisioned by the most popular magazines like *Playboy* or the *New York Times Magazine*. My work is made analog using old magazines, scissors, glue and acrylcolor, even for my 6.5-foot pieces. My work has already been shown in numerous German and international exhibitions.

2. Paper collages and acrylic on whatever, mostly canvas and cardboard.

3. I mostly get inspired by art, music, film, not that much by other illustrators, so I would like to do a collaboration with artists from other disciplines.

4. Magazines and the white walls of every gallery.

5. Work, work, work for some exhibitions that are upcoming in 2008.

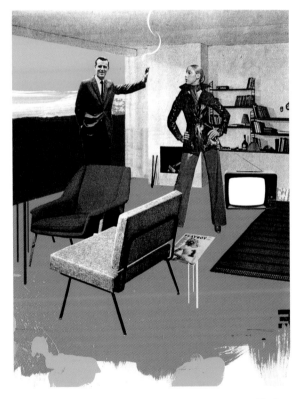

Playboy
Papercollage and acrylic on paper.
2007

Sputnik
Collage and acrylic on paper.
2007

Playstation3-Video
Collage and acrylic on paper.
2007

Playstation3-Music
Collage and acrylic on paper.
2007

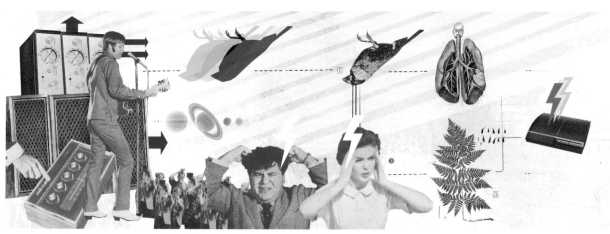

Playstation3-Party
Collage and acrylic on paper.
2007

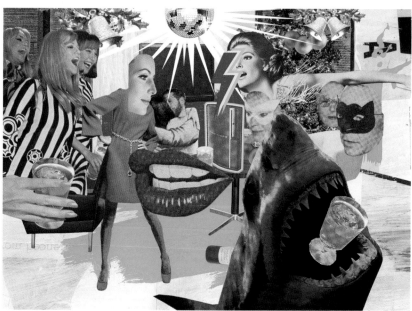

Polo
Collage on cardboard.
2007

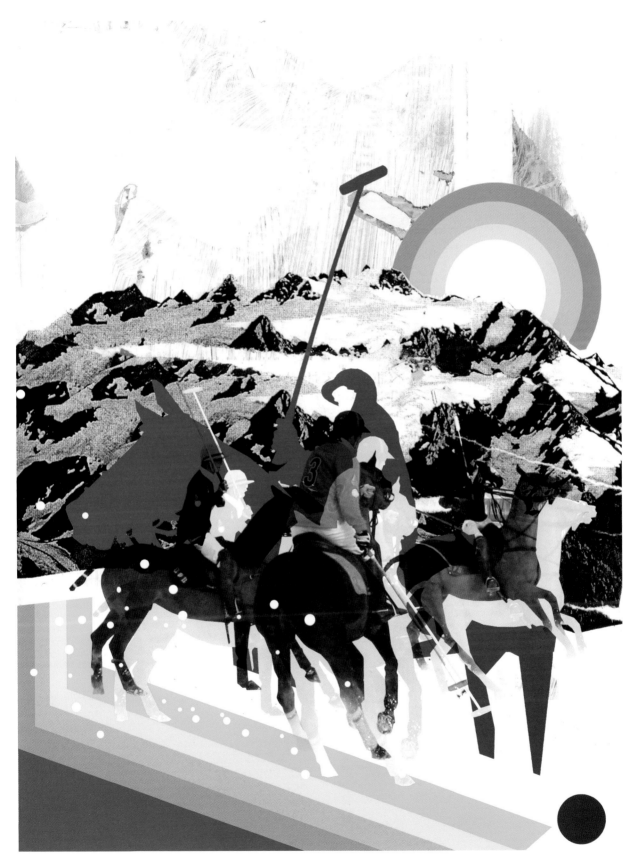

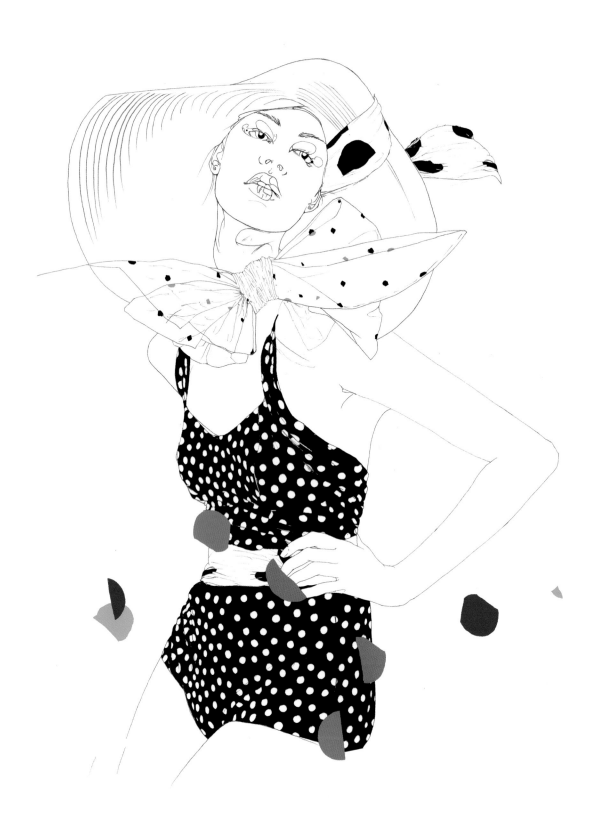

ChristinaK

UK www.dieforlove.co.uk info@dieforlove.co.uk

All images © ChristinaK

1. Illustration as a profession came quite unexpectedly, straight after graduating from college when I was asked to do a few fashion illustrations for American *Hint* magazine and it hasn't stopped since. When younger I was too naive to think it could become my everydayness. Studying graphics in London and working at a fashion magazine in New York opened new horizons and created unforeseen opportunities. I never thoroughly planned my future and I am happy with the way it is evolving so I've decided to leave it like that. A bit vague. I have always been intrigued by fashion, photography, and in a more general sense, visual expression. I always liked crafts and my screenprinting studio is my treasured possession.

2. Nothing more than a well-trained hand. I hand draw using ink and pencils but, the medium is not the secret. The way of using and knowing it is.

3. Tim Walker is on the top of my list of photographers for his outstanding photographic expression and the form of exaggeration which manages to distance reality and create the most contemporary surrealism to date. Egon Schiele for the tension of his lines, the colors, and simplistic compositions, and for being sexually uninhibited in his work. Tacita Dean for capturing space, time and modern myths in the best possible and poetic way. There are many many more to name but I think these really do capture my heart.

4. Probably advertising and fashion but there are always more doors to be opened.

5. It is hard to say but definitely evolving into something finer, more intriguing and different, possibly in a new field of art or accomplishing a combination of a lot of different ones which I am unfamiliar with at the moment. Who can say?

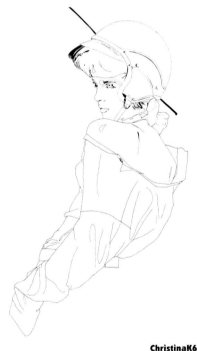

ChristinaK6
Hand-drawn (mixed media) and Photoshop.
2007

ChristinaK8
Hand-drawn (mixed media) and Photoshop.
2007

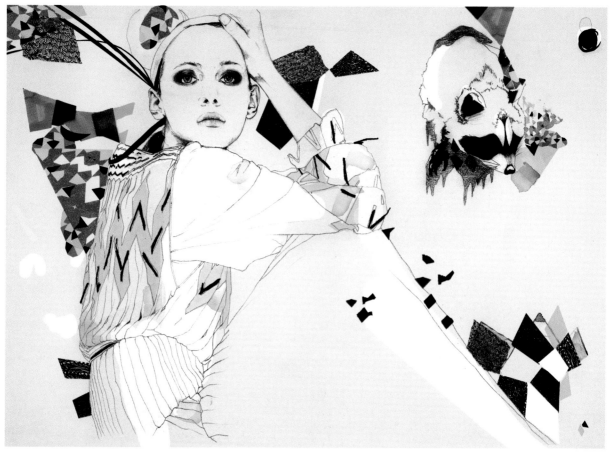

ChristinaK4
Hand-drawn (mixed media) and Photoshop.
2007

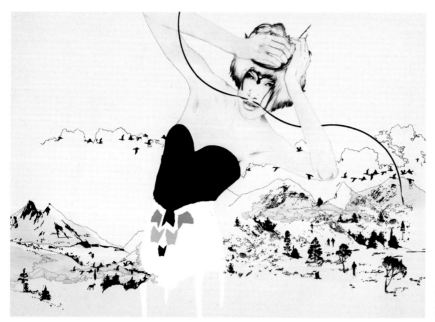

ChristinaK1
Hand-drawn (mixed media) and Photoshop.
2007

ChristinaK2
Hand-drawn (mixed media) and Photoshop.
2007

ChristinaK3
Hand-drawn (mixed media) and Photoshop.
2007

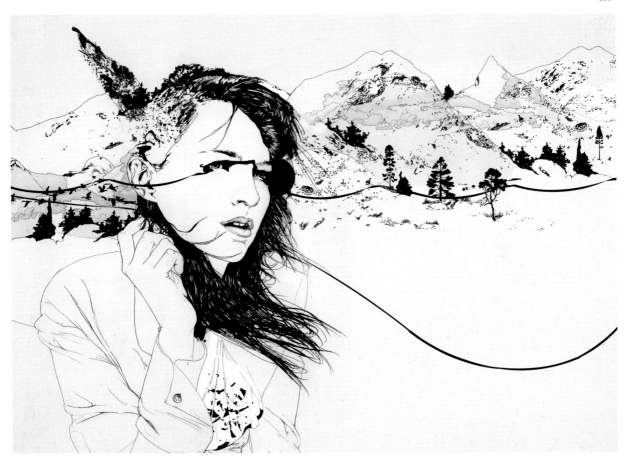

219

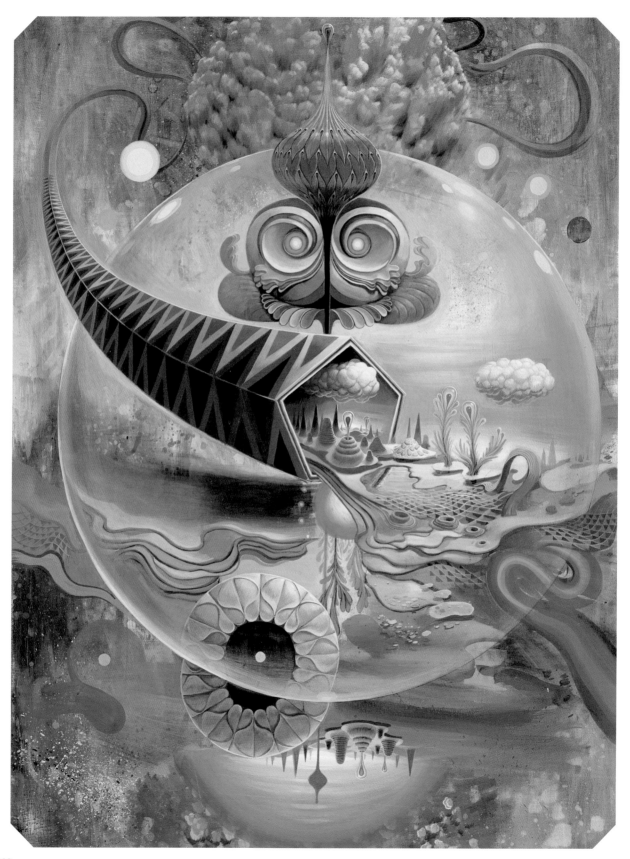

MARS-1

USA www.mars-1.com onemars@yahoo.com
All images © MARS-1

1. Well, for the most part, my illustration days are pretty much behind me. I consider myself more of a fine artist, but I think nowadays the line between illustration and fine art is becoming blurred and harder to define. I guess I still do a bit of illustration work from time to time, but with a very loose framework. It would be primarily album cover art. I love doing it when it's music that I really enjoy.

2. In the early stages of painting, I like to work real loose, without a definitive plan, splashing paint around, building up layers and layers of abstract color and form to stimulate the subconscious mind. As the painting reveals itself to me, I start to home in on the imagery. Toward the end of finishing a painting, it becomes like a puzzle, putting the last pieces in place.

3. Too many to mention. Off the top of my head, here are some of my favorite creative people: Delta, Daim, Os Gemeos, Verner Pantone, Eero Aarnio, Alejandro Jodorowsky, Mobius, Syd Mead, and Ween to name a few.

4. I think there are a lot of people like myself who don't fit well in a specific sector or category, with a wide range of interests, passions, and curiosities. I believe this is reflected in my work.

5. I would be happy just to keep evolving my art and paying my bills!

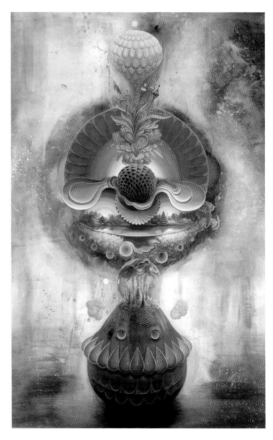

Strange Cargo
Acrylic on wood panel.
2007

Unlock
Acrylic on wood panel.
2007

Game Theory
Acrylic on wood panel.
2007

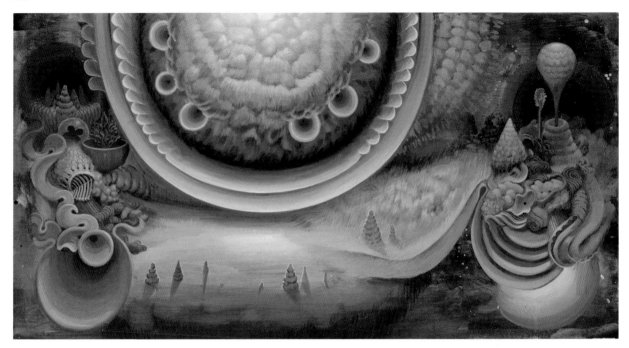

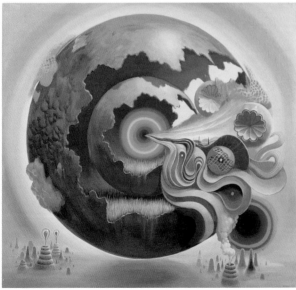

Ultraviolet Dreams#1
Acrylic on wood panel.
2007

Ultraviolet Dreams#2
Acrylic on wood panel.
2007

Thought forms
Acrylic on wood panel.
2007

Aerodynamics for psychonauts
Acrylic on wood panel.
2007

Page 224
Free association
Acrylic on wood panel.
2007